COLONIAL NOIR

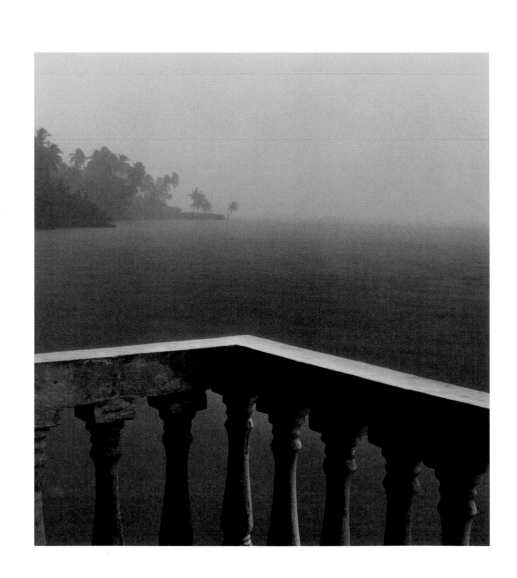

COLONIAL NOIR *Photographs from Mexico*

REID SAMUEL YALOM

STANFORD GENERAL BOOKS *An Imprint of* STANFORD UNIVERSITY PRESS
STANFORD, CALIFORNIA 2004

Stanford University Press
Stanford, California

©2004 by the Board of Trustees of the
Leland Stanford Junior University. All rights reserved.

Printed in the United States of America on acid-free,
archival-quality paper.

Library of Congress Cataloging-in-Publication Data
Yalom, Reid Samuel.
 Colonial noir : photographs from Mexico / Reid Samuel
Yalom.
 p. cm.
ISBN 0-8047-4536-6 (alk. paper)
1. Photography, Artistic. 2. Photography—Mexico. 3. Yalom,
Reid Samuel. I. Title.
TR654 .Y35 2004
779'.092—dc21 2003013462

Designed and typeset by Rob Ehle in 12/18 Adobe Caslon and
Scala Sans display.

Original printing 2004
Last figure below indicates year of this printing:
13 12 11 10 09 08 07 06 05 04

This book is dedicated to Tracy, Desmond, Irv, and Marilyn.

Publication of this volume was made possible by the generous contributions of the following individuals:

Betty Brachman
Deb Culloden and Len Mattson
Paul and Bobbi Glauthier
Irwin Greenstein
Laura Grigsby
Jim Hudak
Jay Kaplan
Mei Yan Leung
Avery Mcginn
The Scott Nichols Gallery
Laurene Powell
Jean Rose
Daniel and Theresa Spitzer
Matt Werdegar
Marilyn and Irv Yalom

CONTENTS

Acknowledgments ix

Foreword xiii
MARK CITRET

Introduction xv
SANTHOSH DANIEL

A Chiaroscuro of Mexican Life xxiii
FREDERICK LUIS ALDAMA

Plates I

Notes on the Plates 75

ACKNOWLEDGMENTS

As a photographer, I tend to work half in the visible world when taking images and half in the invisible world of the darkroom and office. In the former, I visit many places and interact with numerous people, capturing as many interesting images as I can with cameras, film, and other tools of the trade. In the latter, I work alone, unnoticed by what is contained in my photographs, methodically evaluating and eliminating images and polishing the ones I keep; my office overflows with boxes and portfolios of finished photographs. On occasion, these two worlds intersect and what I see in the solitude of my darkroom is seen also by the world from which it came. The publication of *Colonial Noir* is one such moment. The images of this collection are reentering the "visible" world, affording people the opportunity to see what has captured my attention for so many years and allowing me the chance to better understand the relationship between these two aspects of my work. For this, I am especially grateful to two people: Norris Pope, editorial director of Stanford University Press, and Santhosh Daniel, my friend and colleague. Santhosh, as editorial consultant on *Colonial Noir*, has played both an important conceptual role in helping turn a series of photographs designed for art gallery walls into a larger body of images that flow as a book, as well as the more mundane role of editing both words and pictures.

The photographs in this collection were taken between April 1996 and November 2001, and printing of the images continued until February 2003. The conceptual beginning, however, dates back to the summer of 1995 when I had the good fortune to spend six weeks in Indonesia,

on a honeymoon and on a photographic adventure to Sumatra. Interested in how foreign objects interact with indigenous landscapes, I found myself exploring places with my camera that revealed Indonesia's Dutch colonial history relative to its contemporary context of everyday life. This focus combined several elements of my background: graduate studies at the Monterey Institute of International Studies, architectural photography, and interests in Surrealism and Modernist photography.

As I worked, one particular photograph emerged as my signature image and the impetus for starting the *Colonial Noir* series. In "Sumatra Rain" (frontispiece), the colonial elements of the railing contrast distinctly against palms on the lake's promontory; the rain creates both an ethereal mood in the distance and a sharp-edged reflection on the rail in the foreground. This compelling image (Cartesian versus non-Cartesian architectures, European desires to superimpose order and explanation on landscapes unknown) has a visual context similar to the works of De Chirico and Magritte in which objects are imbued with meaning derived from the viewer's own experience or imagination. As I began thinking of other countries that might have similar visual and historical compositions, Mexico, with its important cultural history and architectural legacy, seemed the most relevant to what I had in mind, appealing not only to my photographic interests but also to narrative aspects of my work that have been influenced by Mexican and Latin American literary aesthetics.

In the years following my work in Indonesia, I made five trips to Mexico. Each trip was to a specific region that I grew to know with some intimacy and photographed with a degree of spontaneity, allowing as much geographic and artistic discovery as possible. Along the way, I met a number of people who invited me into their homes and work places, giving me the opportunity to photograph them and their environments. They have been integral in developing the conceptual dimensions of this collection. In particular, I offer my thanks to the people of Guanajuato, Motul, Chiapa de Corzo, Mérida, and Campeche for their generosity of spirit. I have yet to visit a country more cordial and easy to travel than Mexico.

In my development as an artist and in the completion of this project, there are a number of people who deserve my thanks: Mark Citret, my friend and mentor, who has always offered honest criticism, strong encouragement, and a wealth of technical assistance; Fredrick Luis Aldama for his invaluable insight regarding the critical and creative dimensions of this collection; Heather Snider (formerly with both Vision Gallery and Scott Nichols Gallery in San Francisco) for her deep understanding, continual faith, and willingness to show my work in well-

conceived exhibitions; and Mike Blumensaadt, Gavin Clark, Andy Freeberg, Laura Grigsby, Leo Holub (my first photography teacher), Anne Johnston, Steven Josefsberg, Jonathon and Camille Justus, John Kiechle, John Littleboy, Scott Nichols, Judy Norell, Eric Schultz, David Spindler, Fred Verhoeven, and Ben and Wendy Yalom.

Lastly, I would like to thank my wife and partner of many years, Tracy La Rue, for giving me the emotional security necessary to explore the artistic world.

FOREWORD

Mark Citret

I have known Reid Yalom since 1989, when he enrolled in my University of California Berkeley Extension "View Camera" class. It was apparent from the first session that he was eager to learn, quietly ambitious, and very talented. While the class was nominally about the view camera and its uses, he was clearly interested in much more—how to make the camera, any camera, a more expressive tool.

Over the next decade I watched his progress as he worked on a number of photographic projects. At times we worked closely together—for several years in the early to mid-nineties he worked as my photographic assistant—and we've remained good friends since. It's been a personal and professional treat to see his photographs reach their current level, and I'm honored that Reid has asked me to provide a few words for his first published collection of photographs, *Colonial Noir*.

There is a long (at least in the context of photographic history) and noble legacy of Americans traveling to and exploring Mexico with their cameras. Needless to say, I'm not speaking of the hordes of northern tourists endlessly snapping every picturesque and "colorful" scene they stumble upon. I refer instead to the tradition exemplified by the Mexican photographs of Paul Strand and Edward Weston, and suggest that the photographs of *Colonial Noir* reflect the same deep and sincere fascination with the country's people, culture, and architecture.

What is most important to me about this work is the fact that the photographs are beautiful and express a Mexico that I would never have seen except through the filter of Yalom's eye. Ultimately it is the *eye* of the photographer, and not the camera, that makes the photograph. Reid Yalom gives the viewers of this book, through his impeccable photographic craft and, more important, his personal sensibility and insight, an eloquent look at Mexico that they will find nowhere else. I offer him my congratulations.

Introduction

Santhosh Daniel

Following a series of visits to Mexico and Central America in the 1970s and 1980s, Reid Yalom began the *Colonial Noir* project in 1996 with the nominal intent of fashioning a historical retrospective of Mexico as seen via its colonial architecture. Tracing various physical routes of Mexican history—from the trail of Cortés to cities bearing the first histories of Independence—he initially produced a series of images reminiscent of Henry Ravell's photographic series "Vanishing Mexico" and works by Guillermo Kahlo celebrating the architectural landscape of colonial Mexico. Set in pools of nostalgia that reflect a seemingly static dimension of Mexico's history, many of these early compositions display a deep appreciation for the antiquarian beauty of Baroque and Neoclassical architecture, but also serve as powerful innuendo regarding the oppressive effect of colonialism on a once-vibrant indigenous landscape.

Although strains of this initial project persist throughout *Colonial Noir*, as a photographer influenced by modernist architectural photography and movements such as Surrealism and Abstract Expressionism, Yalom gradually shifted his interest to consider colonial architecture through an imagistic counterpoint of modernity. Using the ambiguity of night photography to imbue his images with a metaphoric alter-ego, he began to reveal a strong human presence via shadow and chiaroscuro—an aesthetic factor evocative of the subterranean quality of Brassaï's *Paris by Night* collection and in conscious homage to works by the French painter René Magritte—to represent colonial architecture as representative of both the cultural moment in

which it was conceived and the subsequent generations that continue to perceive and interpret its meaning. Embedding references to architectural modernity (such as Mexican Positivism and International Style), Mexican industrialization and Revolution, and authors such as Julio Cortázar and Jorge Luis Borges to amplify this sensibility,[1] his images then began to shed the inert quality of a simple historical retrospective and consequently reveal a much broader project: colonial architecture now appeared to express a question of cultural consciousness as proposed by the turbulent energy of Mexico's postcolonial evolution.

By shifting from an isolated investigation of colonial architecture to now focus on Mexican cultural consciousness (and, thereby, questions of cultural identity), Yalom was acutely aware of the difficulty of creating images of a culture to which he did not belong. Although he drew considerable influence from and could claim citizenship within an extensive lineage of foreigners who have photographed Mexico—many of whom, in the nation's early, post-Revolutionary history of cultural exchange, were influential in shaping an "image" of Mexican culture via a foreign yet "Mexican" aesthetic of photography[2]—works by contemporary Mexican photographers such as Flor Garduño and Pedro Meyer, which investigate identity from an interior perspective, seemed to diminish the cultural authority of such ancestry. Similarly, despite recognition by a number of Mexican photographers of the value of a "foreign" perspective when photographing Mexico,[3] Yalom's sense of cultural restriction was heightened by awareness of Mexican photography's movement away from an identity derivative of its European origins and of early– to mid–twentieth-century North American flourishes—a trend inaugurated by Pedro Meyer's call in the late 1970s directing (Mexican) photographers to reclaim the content of all images of Mexico and its people as originating from the historical imagination of Mexicans.

In considering how best to approach his subject, Yalom eventually decided to make this conflict the new focus of his images: to recontextualize colonial architecture as an artifact representative of both the genesis of Mexican national identity and the phenomenon of cultural exchange (that began via colonialism) from which his interest in Mexico evolved. Given this frame of consideration, his subject now seemed to mark a point of origin for not only questions of Mexican cultural identity that followed colonialism (i.e., the *mestizo*, modernity, "folklore," etc.), but also Mexico's uncertain harmony with a history of foreign influence firmly embedded

in the "making" of its cultural image.[4] Most important, this acknowledged the origins of influence that brought Yalom to Mexico, thereby allowing him to investigate directly his own cultural consciousness in regard to his subject and subsequently question the unsettling "colonial" undertone of his images—an aspect strongly expressed in a sequence of images, beginning with "Watchtower," in which a feeling of desolation and cultural isolation appears to sublimate, in "Escape," into the photographer's own shadow.

In blurring the boundary between photographer and subject, this reinterpretation marked a decisive moment in the project's evolution, as Yalom's symbolic gesture to project himself into his images—as he moved between the staid objectivity of a historian, the social realism of an anthropologist, and various apertures of artistic modernity—created a perspective with no fixed point of interpretation. In tandem with the surrealistic qualities of night photography, the effect was to then create an ambiguous psychological terrain in which Yalom and Mexico—or, the "foreign object" and "indigenous landscape," as mentioned in his acknowledgments—merged in a state of uneasiness, wandering the convolutions of culture in search of a unified perspective that Yalom eventually identified as *noir*.

As a counterbalance to the relatively static atmosphere of colonial architecture, *noir* allows for a number of interpretative possibilities,[5] and from the standpoint of visual convention it is easy enough to see why many images deserve the classification: "Bike Shadow" reveals a scene suspended by innuendo and ribbons of light; "Theatre Stairs" gains life via the sensation of vertigo; and "The Undertaker Rises Early" takes on a quality reminiscent of cinematic stills from Hollywood film noir. Unmistakable, however, is Yalom's understanding of noir as more than a simple visual modifier, in particular, the implications of noir's modernist origins on romanticized images of colonial architecture and noir's cultural importance in regard to foreign and indigenous representations of Mexico.[6] Most important, though, his use of noir is a reflection of his difficulty in finding culturally definitive representations of Mexico, ensconcing images with a mood of uncertainty—a defining characteristic of noir generated by the absence of visual and conceptual symmetry—to reveal the landscape he sees as both a foreigner and a photographer.

In the moral ambiguity of "Pinocchio" or the cynicism of "They Say She Lost Her Head in the Revolution," Yalom uses the undertones of noir to cultivate a thematic in which Mexico pursues variables of the past into its present and future: inset within the dissonant framework of

light and dark, his "Eastern Cannon" points at the residue of its own memory or the canon of colonialism it once protected; three men illuminated by sacramental light appear to study their silhouettes in shades of the colonial church in "Cathedral Light"; and a woman rests in the arch of a fort and the archetype of folklore as she considers the passage of time in a faded mural in "Woman Leaning." He then complements these compositions with colonial architectures languishing in a state of melancholy, abandoned in a funnel of romantic disillusionment—or, as in "Alhóndiga de Granaditas," inhabited by children who seem to have only a playful interest in their cultural value—essentially using a noir sensibility to interpret his subject while at the same time coaxing his subject to personify noir.

Yet even as Yalom confers meaning to these images via noir, he is also developing a set of counterimages that question his interpretations and acknowledge the cultural distance from his subject: creating scenes in which Mexican culture appears to contract in the presence of the "foreigner," a man appears to enlarge history in a moment of privacy in "Reader"; men walk, backs turned and thoughts cloistered, in "Old Friends"; and a woman's gaze falls on nearby companions but remains partial and unavailable to the photographer in "Smile II." Similar to Mexican landscapes of classic film noir, in which Spanish is often spoken without translation or subtitle to amplify a sense of the unknown, Yalom depicts the narration of a public secret to which he is not entirely privy, and subsequently, those images that do allow a viewer to enter an interior mindset of Mexico are then contradicted by images such as "Theatre Doors," where he appears to enter a space abandoned minutes before his arrival, or perhaps most strikingly, by the subject in "Woman Leaning" as she faces away from the camera, guarding her introspections of culture from the photographer, to imbue the image with an aura of suspicion.

Exploring the relationship between himself and Mexico as though both were characters in a noir narrative, Yalom finds a common point of understanding in the ambiguity of self-interpretation; collectively, *Colonial Noir* illustrates his attempt to understand what compels him to photograph Mexico and Mexico's investigation of itself vis-à-vis its colonial legacy. And similar to Orson Welles's noir classic *Touch of Evil* (1958)—a film Yalom acknowledges as influential to this collection—in which narrative landscapes alternate between Mexico and the United States, *Colonial Noir* embraces this duality. Thus, we find him juxtaposing the self-reflexive reality of "Painted Tree" with the nefarious history of "Alhóndiga de Granaditas" to create a similar narra-

tive equilibrium. Inherent within this dichotomy is the question of cultural exchange, the collaborative moments between Yalom and Mexico that blend with the collection's underlying conflict to reveal a distorted sense of unity in "Loveseat" or the innuendo of "Bananas"—an image provoking thoughts of economic revolution, multinational exploitation, and factors of urbanization that have led both Mexican and foreign photographers away from bucolic images of Mexico toward the metropolis and *urbanismo*.

Ultimately, Yalom applies a cumulative sensibility of noir to the entire collection, interspersing moody nighttime sequences with sudden bursts of daylight and shifting between incongruities of real time versus imagined time, to present a perspective free of both visual and conceptual conclusion—a common trait of any noir work. The only guide then given to a viewer is a set of photographic notes—or Notes to the Plates—that function as noir-like "voice-over" regarding how a project of colonial architecture eventually transformed itself into an ethereal landscape of noir.

In discussing the evolution of *Colonial Noir*, from its conceptual origins in Indonesia to completion in California seven years later, Reid Yalom frequently mentions that it was the surrealism of colonial architecture that eventually led him to discover the noir aspect of the collection. At first glance, this can be interpreted to be a reflection of his interest in the combined effect of night photography and artistic modernity on any image, or, as he writes in his acknowledgments, his interest in "postmodernist approaches to modernist photography." However, given that Yalom was initially seized by the antiquarian appeal of Mexico's colonial architecture, this "surrealism" can also be interpreted to be the byproduct of his interaction with and investigation of a culture that regards such structures in multiple and living dimensions of time, place, and politics.[7] A comparative psychology that can split a vision of Mexico into perspectives of the foreign and indigenous, it is also a preface as to how the process by which Yalom understands Mexico is equally important as the image he produces.

As Frederick Luis Aldama describes, ultimately the images of *Colonial Noir* can only be understood by means of the imagination. It is a work where cultures underscore histories and undertones supersede interpretation, an ambient space where noir can draw a viewer into existential moods of Mexico and the imagery one discovers often lead to the history of a country

colonized by images. An imagined place in which subjective iconographies of birds, guitars, and horses are created as carousels spin into darkened recesses of forts, cathedrals, and *zócalos*, it is also the intersection by which "Pinocchio" can pay homage to Paul Strand's "Cristos" and suggest enduring legacies of colonialism, or express a photographer's own sense of irony as he attempts to shape a true image of Mexico.

NOTES

1. Yalom also references the Colombian authors Alvaro Mutis and Gabriel García Márquez (see "Maqroll at Rest" and "Water Jug") and the Chilean poet Pablo Neruda (see "Bananas" and Neruda's "La United Fruit Co.") to emphasize Mexico and modernity (and postmodernity) vis-à-vis a Latin American literary aesthetic.

2. Yalom cites U.S. photographers Edward Weston and Paul Strand and French photographer Henri Cartier-Bresson—all of whom composed substantial bodies of work in Mexico and are primary figures in development of the "Mexican" aesthetic—as influential to *Colonial Noir*.

3. "Of course, this preoccupation with the most exact and incisive view of ourselves, capable of transcending the deceiving veil of the external stamp, motivated in Mexico one of the most interesting currents of thought in the twentieth century: our reflection of the Mexican being, that evident reality, which nevertheless escapes view, that substance present and absent, invisible and ungraspable, for whose comprehension we have needed, too, the vision of foreigners" (Victor Flores Olea, "Una revelación / A Revelation," in *México: Visto por ojos extranjeros / México: Through Foreign Eyes, 1850–1990*, ed. Carole Naggar and Fred Ritchin [New York: W.W. Norton, 1993], 15).

4. Consider, for example, the inherent conflict of interpreting seminal works by Mexican photographers Manuel Álvarez Bravo and Lola Álvarez Bravo—who comprise the "indigenous" backbone of modern Mexican photography and are central figures in the discussion of Mexican cultural image and identity—without noting the influence of French and Italian photographers Henri Cartier-Bresson and Tina Modotti or U.S. photographers Edward Weston and Paul Strand.

5. *Noir*—derived from *film noir* ("black film," Fr.), an ambient style of cinema with roots in German Expressionism that flourished in the anxiety, pessimism, and suspicion of post–World War II United States—is often used in describing night photography, the byproducts of which (attenuations of shadow, distortions of light, and chiaroscuro) can swell an image with innuendo and a sense of mystery. Evocative of the moody cultural underworlds typified by classic film noir works such as *The Maltese Falcon* (dir. John Huston, 1941), *Double Indemnity* (dir. Billy Wilder, 1944), and *The Blue Dahlia* (dir. George Marshall, 1946), noir can also refer to any number of compositional factors—skewed camera angles, disorienting lighting, unbalanced visual schemes—used by photographers to draw a viewer into psychological convolutions of both character and landscape and cultivate moods of philosophical unease. An ephemeral blend of form and content, *noir* has as defining characteristics a narrative marked by undertones of moral conflict, suspicion, melancholy, and disillusionment; the suspension of linear or chronological time, typically expressed through flashbacks; voice-over; and characters driven by a conflicted past and/or an obsessive questioning of their own sense of reality.

6. In the North American vernacular, *noir*—or rather, film noir—has often used Mexico as a backdrop for many of its classic productions, relying on a combination of high-contrast cinematography and ambivalent caricatures of Mexico to create impenetrable subcultures that amplify a character's uneasiness and sense of the unknown. Certain films, such as *The Big Steal* (dir. Don Siegel, 1949), show the country as a place where characters find relative freedom in the uncertain

dimensions of an indecipherable landscape. Others, such as *Out of the Past* (dir. Jacques Tourneur, 1947), depict Mexico as a counterdestination to the moral corruption of the United States, a place of escape that resonates deeply with the motive of a number of photographers, such as Paul Strand and Anton Bruehl, who came to Mexico in the early twentieth century to distance themselves from the rapid industrialization of Europe and North America; an idealized vision of Mexico with overtones of the exotic, it also represents a classic device of film noir—the character propelled by his pursuit of an iconoclastic vision: the Maltese Falcon as the American Dream or the banal glowing briefcase in *Pulp Fiction* (dir. Quentin Tarantino, 1994).

7. Yalom frequently mentions that it was his interest in the reliquary sensibility of the Spanish mission in California (e.g., the Basilica of the Mission San Francisco de Asís in San Francisco), as opposed to the progressive cultural sensibility of colonial architecture in Mexico (e.g., the Palacio Nacional in Mexico City—a frequent site of contemporary political protest whose history begins with Cortés and Moctezuma II and whose physical architecture, partially rebuilt after riots against Bourbon rule in 1692, houses the current headquarters of Mexico's central government and a number of murals by Diego Rivera, including "México a través de los siglos / Mexico Through the Centuries"), that formed the basis by which he first considered colonial architecture of Mexico as a possible subject.

A Chiaroscuro of Mexican Life

Frederick Luis Aldama

Colonial Noir can be likened to a hall of mirrors that cuts contrastive shadows between light and dark, its many corridors of images intersecting and colliding to create both closed doors and open windows, interiors and exteriors, and all the concomitant in-between spaces that are Mexico.

Waxing poetic on the art of writing, Julio Cortázar once applauded the author who could transform "the simplest sentences into a play of mirrors that multiplies the dangerous and fascinating side of the character."[1] While there are no "dangerous" characters as such in *Colonial Noir*—the collection indeed sidesteps snapshot representations of Mexico as a baroque abundance of people—Reid Yalom does deploy a Cortázarean transformation: through his keen use of photographic grammar (light, frame, and mise-en-scène), he turns "real" imagery into a poetic "play of mirrors." With Cortázarean precision and a poetics built on the negation seen in Pablo Neruda, Jorge Luis Borges, and Elena Garro, Yalom's minimalist vision paradoxically subtracts in order to amplify; the result is a sense of Mexico that engages the eye while refusing to be contained within the photographic frame. In the absenting of figures and objects that might clutter the mise-en-scène, *Colonial Noir* thus captures with formal concision the lived space of Mexico.

Images of doors and windows—openings outward—abound. Mexico is just such architectured spaces, allowing warm light to pass into cold, estranging interiors; it is the juggle of light and dark on walls and through doorways at dusk. It is the gateway of a colonial fortifica-

tion, looking not inward to yesteryear's death and destruction but outward as far as the eye can see. It is the promise of new life beyond the window frame where clouds roll over distant horizons; it is Tlaloc, the blind god of fertile rain, carrying then letting go of his heavy burden. It is languid light and sometimes unnerving silences.

Images of man-made objects such as cups, cannons, crosses, keys, and benches point to the Mexican as *Homo faber*, while also hinting uncannily at the alchemy of synesthesia, that union of the senses where sound becomes light or odor has taste. Disturbing, too, are the images of curtains, doors, windows—gatekeeping objects that separate one living space to another, exterior from interior, suggesting passage, whether to the familiar or to the unknown, and fueling the imagination and the drive to know. Functioning similarly are images of empty containers, of the lone street vendor who pushes his cart in a street seemingly airless and empty of sound. These photographs serve as markers of Mexico's many-layered civilization and achievements.

Avoiding the nostalgic mood of the sepia wash, these images rely on contrastive light and dark to depict objects worn and frayed from use, objects that reveal, as Neruda muses, "the confused impurity of the / human condition, the massing of things, the use / and obsolescence of materials, the mark of a hand, / footprints, the abiding presence of the human that / permeates all artifacts."[2] Other objects unfold—*santero* figures, candles, chests in incongruous places: have they lost their way, or perhaps their owners have strayed? Their forlorn position in the world is forever fixed by the photographic image.

Then there are Yalom's photographs of wrinkled, labor-worn, arthritic hands, powerfully reminding viewers that objects (present or absent) are of our creation. These determined, prevailing, tired hands are not intended to inspire romantic reveries of Mexico. Rather, they reflect the knowledge and experience invested in the creation of objects and beautifully architectured spaces. Hands like these possessed the skills to build the now silent cannon, to carve the now worn colonial-era shutters that allow light to filter in and out, and to build the library whose shelves Yalom depicts. Such hands also made the sheets of paper in the books on those shelves, now stained, yellowed, or marked, impatiently awaiting the delicate touch of an attentive reader. And hands like these may have written down stories of loves lost or won, of dreams achieved or faded, of doubts conquered or certainties dashed, of anger repressed and hatred unleashed—stories now contained, perhaps, in those same pages. In these hands we find a token of the unceasing striving and creativity that have been a mark of humankind since its dawn.

As the photographs move from interior to exterior, window to door, house to landscape, they resist depicting the country's majestic skies and mountains and the hieratic faces of its suffering *campesinos*, as evoked for example by Sergei Eisenstein in *¡Que viva México!* (1931). Nor, for that matter, do they slip into the baroque or "exotic" imagining nowadays so fashionable, peddled by legions of formulaic authors and artists in the wake of Gabriel García Márquez's hugely popular *One Hundred Years of Solitude*. Instead, Yalom's images stand out in their extreme sparseness and austerity, a quality that lends an ontological weight and substance, together with a wealth of meaning and feeling at once stirring and soothing, unattainable by the populist and baroque approaches. By demanding that we abandon any folklorist expectations and by paring his representation back to the barest of essences, Yalom teaches us to see a new reality, one rendered abundant by myriad imaginings. His is a use of Occam's razor with a vengeance.

Mexico's culture—layer upon layer of pre-Columbian, colonial, and postcolonial legacies combined with ever-present reminders of Mexicans' incessant toil—comes alive as Yalom's gallery of photographs unfolds, showing gates, fortifications, cobblestone streets, church bells, stranded boats. Such images evince a basic paradox of human existence: that our presence in the world is felt only in an absence, as symbolized by our acts, by what we have done and created, by the crystallization of work—objectifications of time and space. Yet that absence is not just a present that enacts a past, but an opening, a projection toward the future, a wealth of potentialities urging us to make actual. It is this that the *Colonial Noir* collection reflects and intends us to see.

Interior spaces speak to the life—and death—and all the creations, thoughts, dreams, pleasures, hopes, and pains that make up ordinary, everyday life in Mexico. They speak to the places that provide sanctuary from external chaos and allow individual memory to congeal and dream to take flight. Octavio Paz, who calls those spaces "the center of the world," seems to put words to Yalom's images when he speaks of us as "adrift / in the foundering cities, rooms and streets, / names like wounds, the room with windows / looking out on other rooms / with the same discolored wallpaper, / where a man in shirtsleeves reads the news / or a woman irons; the sunlit room / whose only guest is the branches of a peach; / and the other room, where it's always raining / outside on the patio and the three boys / who have rusted green."[3]

The room-spaces in *Colonial Noir* transcend any division between the art of photography and the art of painting: walls liquefy into oceans, doors sprout wings and fly, and ceilings melt

into starry nights. These images transport me to my childhood in Mexico and my first experiences of delight in the world: the smell of *pan dulce* and the taste of *chocolate caliente*, the sound of the vendor ringing his bell to announce the arrival of multicolored shaved ice and the sight of the multicolored piñata breaking open and unloading its treasure of fruits and candies, and the feeling of warm brown or white arms holding and hugging me. These images also echo loudly with my first grand triumphs, such as learning to walk in and out of doors without falling on the steps, or realizing that church attendance for weddings and baptisms could mean, beyond the boring solemnities of such occasions, eating cake and having great fun—or achieving an early envisioned independence by being granted a room of my own.

Space in *Colonial Noir* is also the time of Mexico—a spatial time, given substance in the absent-present bodies of visitors and inhabitants alike. It is a Mexican time where people grow (time) and act (time) and reach old age (time) and cease to act (time); a Mexican space of human-made change (time) that transmutes (time) into a virtually infinite variety of forms of life (time). This temporal connectivity gives *Colonial Noir* a clear literary correlate in Juan Rulfo's novel *Pedro Páramo*, which so beautifully captures the experience of space as time—such as when Juan Preciado walks into the town of Comala and hears human echoes trapped behind walls and under the cobblestone streets; or when Juan Preciado looks into doorless houses where light trickles in through roofless ceilings and where, instead of meeting people, he feels the powerfully muted presence of absent voices and bodies.

In exploring the play of light and reflective surface and the imagery of windows looking out and in, *Colonial Noir* foregrounds the visual process, in which the retina acts as a bridge between self and the world. Both his approach and his subject matter promote new ways of experiencing the touch of light, as objects are shaped by their shadows. Yalom's approach mirrors Octavio Paz's vision: "With shadows I draw worlds, / I scatter worlds with shadows. / I hear the light beat on the other side."[4]

As mentioned above, although *Colonial Noir* refigures Mexico in many ways, the most consistent mode of representation is as a series of windows and doors that divide space into inside and outside: an inside space that is hospitable, protective, nurturing, peaceful, allowing for a secluded life of art and thought as well as the intimate joys of sex and food and music; and an outside space that can lead to the unfamiliar and unknown, the many-sided risks of freedom and the supreme flights of fancy—that can be as beautiful and pleasurable as the one

inside, or the opposite: dangerous, menacing, and inhospitable. An open window attracting vision toward an inside space or, conversely, impelling it outward into the world therefore opens up infinite possibilities; in this manner a very special synthesis is nurtured, where objects have many points of contact with the human mind and are revealed to be powerful forces in the motivation of human actions. In Yalom's work, therefore, a window or a door can be an authentically sublime aesthetic experience, similar to the one produced by the monumental paintings of José Clemente Orozco, such as his powerful mural *El Hombre* in the Cabañas hospital in Guadalajara, or by Frida Kahlo's interiors, with their multitude of mirrors reflecting inside and outside space in harmony with one other. As José Donoso and Julio Cortázar have shown in their short stories and novels, a mystery palpitates behind closed doors, a mystery that demands to be known and explained. Doors provide access to knowledge, and also to dreaming and imagining. A door, a window . . . these are paths to Mexico and to its people, its art, its literature, its music.

Colonial Noir is also a repertoire of images of grand expanse: views from balconies, looking out over distant tropical mists; cannon barrels stretching out toward the distant horizon. Church bells ring out toward *el cielo* instead of remaining secluded in cloisters, chambers, and alcoves. *El cielo* (meaning both "sky" and "heaven" in Spanish) opens out, pointing beyond interior spaces; clear or dark skies confabulate with the sun to decide on human fate. Those large expanses, of sky, of landscape, are also part of what it means to dwell in the world. Once again, Octavio Paz comes to mind: "If this beginning is a beginning / it does not begin with me / I begin with it / I perpetuate myself in it / Leaning over the balcony / I see / this distance that is so close / I don't know what to call it / though I touch it with my thoughts."[5]

Other suggestive images in *Colonial Noir* are those of boats and masts. Seeing them brings to mind *The Adventures and Misadventures of Maqroll the Gaviero* (the Lookout), an indefatigable world traveler and modern-day Don Quijote conceived by the great Colombian poet and novelist Alvaro Mutis, as well as the poems in which Pablo Neruda celebrates the life of seamen wandering in the hope of reaping great harvests of "fruits of the water." More personally, these images make me think of a time when I was standing at the port of Veracruz, hearing the sounds of waves slapping against the walls of the harbor mixed with the calls of seagulls and the hullabaloo of the many peddlers, the passers-by going about their business and the dock workers performing their duties. I had been taking in all the odors coming from the sea and the port, and

my feet had started to feel the weight of my young but tired body. Also, I was a bit lightheaded because I had not had a wholesome meal in a while (just as I had not been caressed by a loving person in a long time). Then, along came a man who started taking pictures of me staring at the horizon. Imagining that I could read his intentions with great accuracy, I thought: "This man seeks a photographic representation of the fullness of space in this place, a representation that will teach viewers how to perceive in new and unexpected ways the space they inhabit and the space that constitutes their very being." He took many shots from various angles while I remained still, keenly aware both of his presence and of the sensual impressions I was registering. I was certain the photographer was looking for the empirical correlate of an image he carried in his brain—an ideal, an archetype of space—and that he felt all his shots were clumsy and blind. Finally, though, he aimed his camera away from me, toward the inscrutable horizon. And that, I gathered from his chuckles and other manifestations of joy, was it, that was what he had been looking for. There and then I perceived along with him that wide seeming emptiness, or that apparently infinite fullness, the shock of raw space as it can appear only in its immediacy, when all the senses become aware of—in a single fraction of a second—the inevitable presence of space through its glorious absence.

To really see a photograph is to appropriate it, to be transfigured by it. It's the same process at work when we read a work of literature, as Jorge Luis Borges reminds us: "When the book lies unopened, it is literally, geometrically volume, a thing among things. When we open it, when the book surrenders itself to its reader, the aesthetic event occurs. And even for the same reader the same book changes, for we change; we are the river of Heraclitus, who said that the man of yesterday is not the man of today, who will not be the man of tomorrow. We change incessantly, and each reading of a book, each rereading, each memory of the rereading, reinvents the text. The text too is the changing river of Heraclitus."[6] And so it is with the images in *Colonial Noir*, among which I single out "Bound Book" as connecting all the other images and thus linking the inanimate with the animate, the mirror with the reflection, the hand with the object it creates, the window with light and shadow, the living with the dead.

Colonial Noir is a poetic invitation to explore Mexico's interior and exterior spaces, ones suggestive of deep memory and enduring hopes. This image-repertoire based on chiaroscuro affirms being within lack of being; in its eloquent silence it makes room for the creative gaze and imagination. As Alfonso Reyes writes, "Mexico is at once a world of mystery and clarity: clarity

in her landscape, mystery in the souls of her people. The dazzling light sculptures objects and brings them close, naked and glowing, offering temptations to the eyes. Mountains shimmer in the distance; on the volcanoes snow glistens amid rose and silver tints. . . . There is no mist, only clouds, bright-edged and so firmly molded they seem almost tangible. Instead of color there are strong contrasts of light and shade; the effect is stark sincerity."[7]

Traveling through *Colonial Noir* evokes the delicate interplay of arching shadow and light, in turn echoing the absence-presence of time, space, and bodies that make up Mexico. In the end, *Colonial Noir* allows the viewer to experience the full presence of Mexico through its radical absence.

NOTES

1. Julio Cortázar, "A Change of Light," in *A Change of Light and Other Stories* (New York: Knopf, 1980), 250.

2. Pablo Neruda, "Some Thoughts on an Impure Poetry," in *Windows That Open Inward: Images of Chile*, ed. Dennis Maloney (Buffalo, N.Y.: White Pine Press, 1999), 49–50.

3. Octavio Paz, *Piedra de sol* (Sunstone), trans. Eliot Weinberger (New York: New Directions, 1991), 33.

4. Ibid., 142.

5. Ibid., 24–25.

6. Jorge Luis Borges, "Poetry," in *Seven Nights*, trans. Eliot Weinberger (New York: New Directions, 1984), 76–77.

7. Alfonso Reyes, "Roots: Prologue for a Film," in *Mexico in a Nutshell and Other Essays*, trans. Charles Ramsdell (Berkeley: University of California Press, 1964), 14.

P LATES

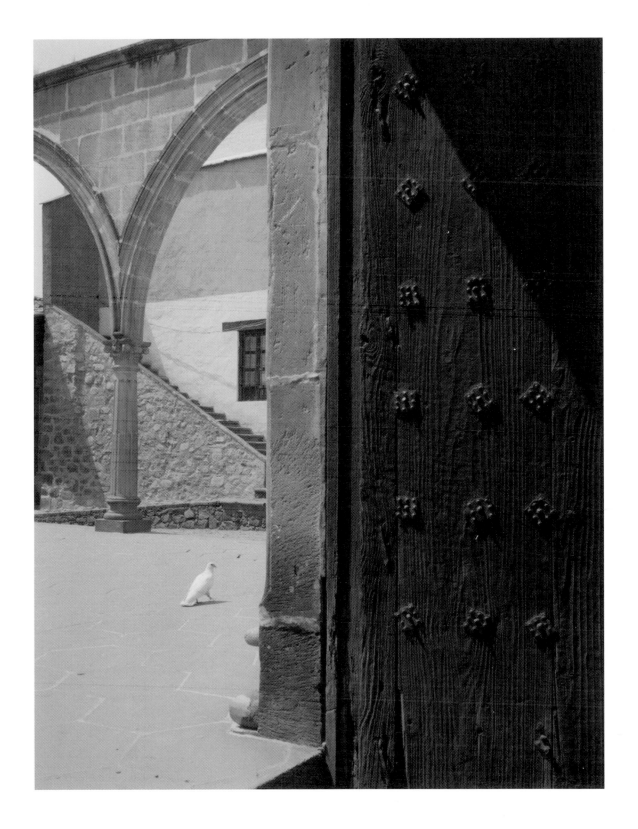

ELEVENTH COURTYARD | 1
Pátzcuaro, 1996

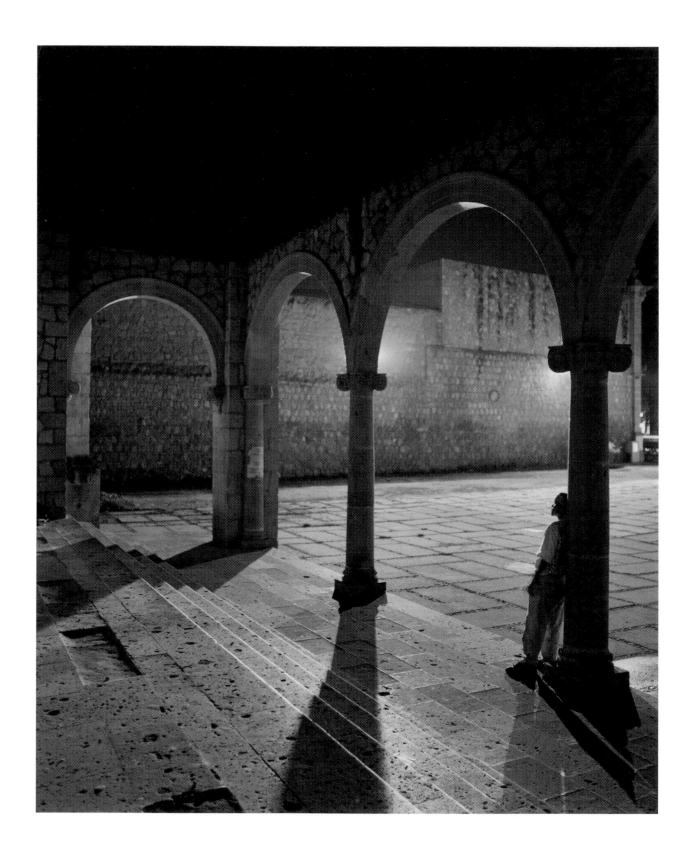

2 | NIGHT WATCHER
Morelia, 1996

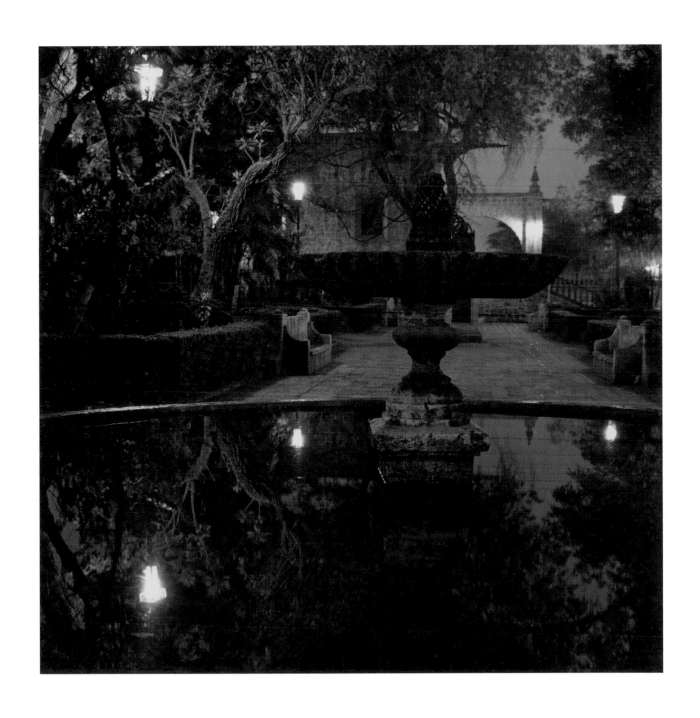

NIGHT FOUNTAIN | 3
Morelia, 1996

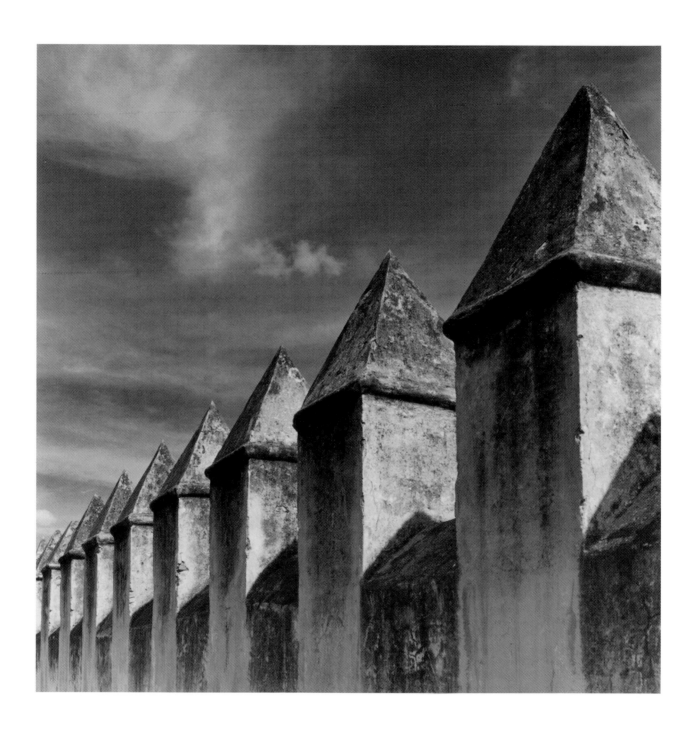

4 | ROOK
Cholula, 1998

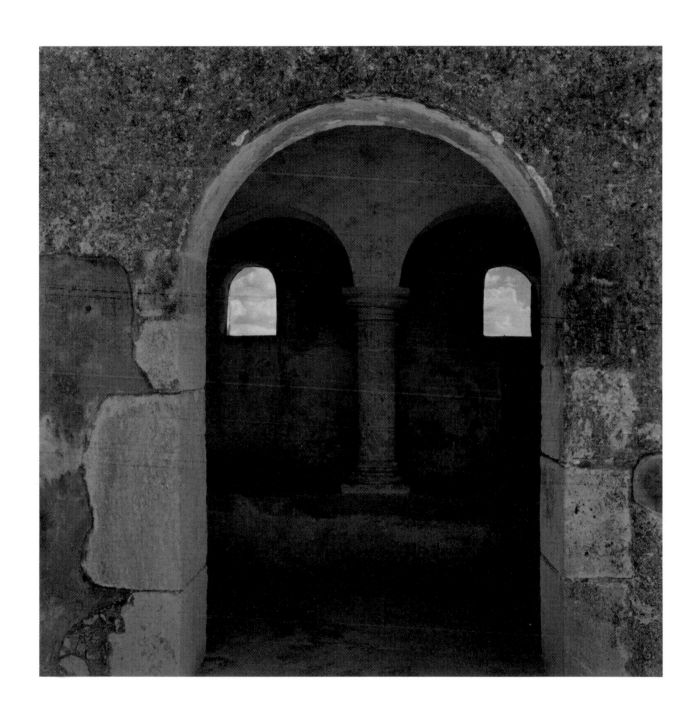

TOWER EYES | 5
Campeche, 2001

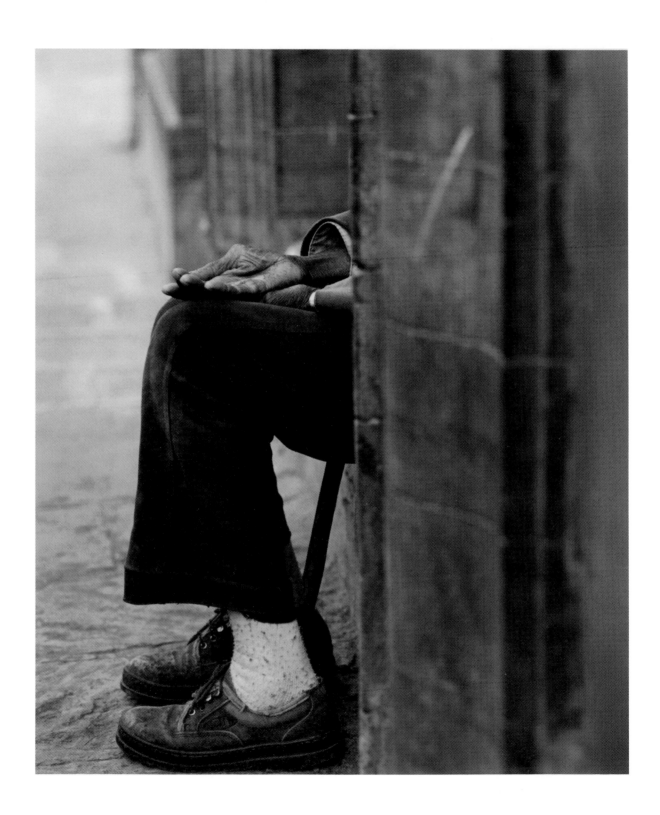

6 | OPEN HANDS
Morelia, 1996

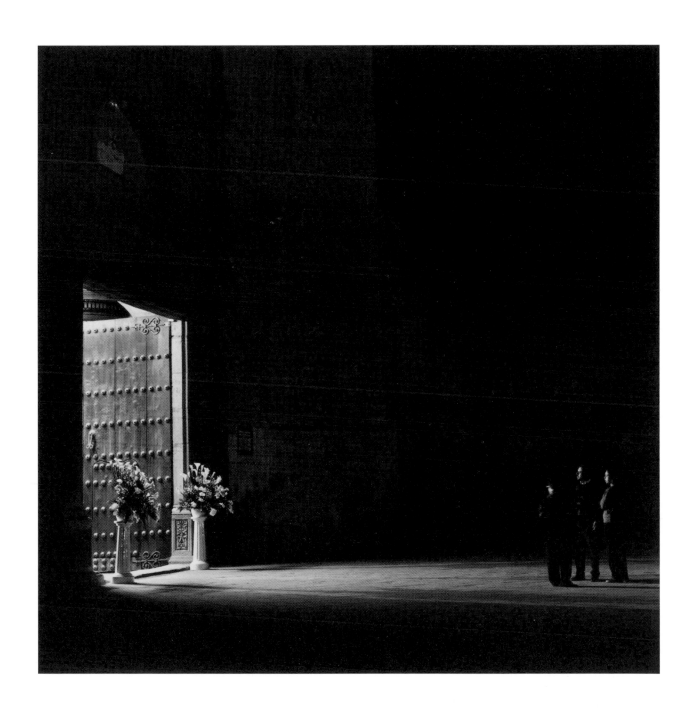

CATHEDRAL LIGHT | 7
Cholula, 1998

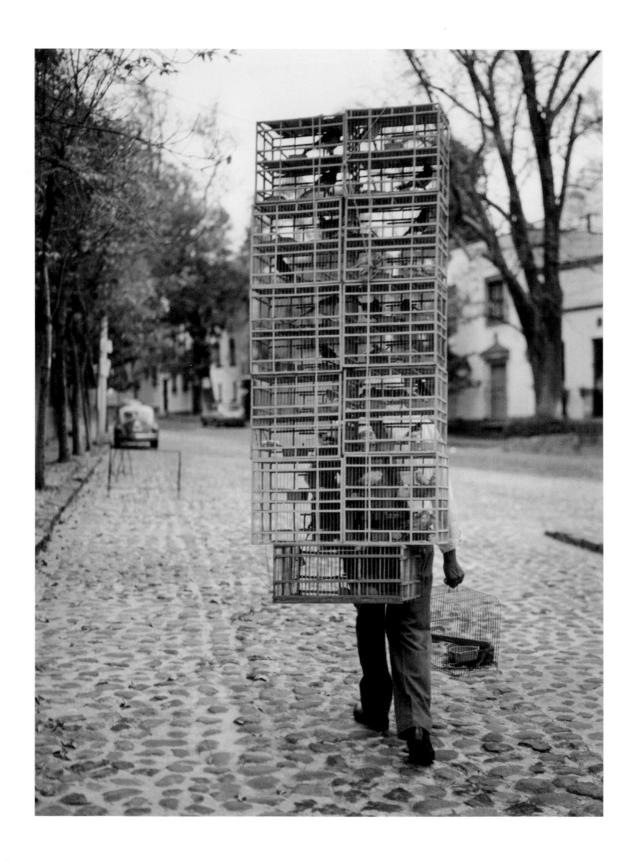

8 | BIRD-SELLER
Mexico City, 2001

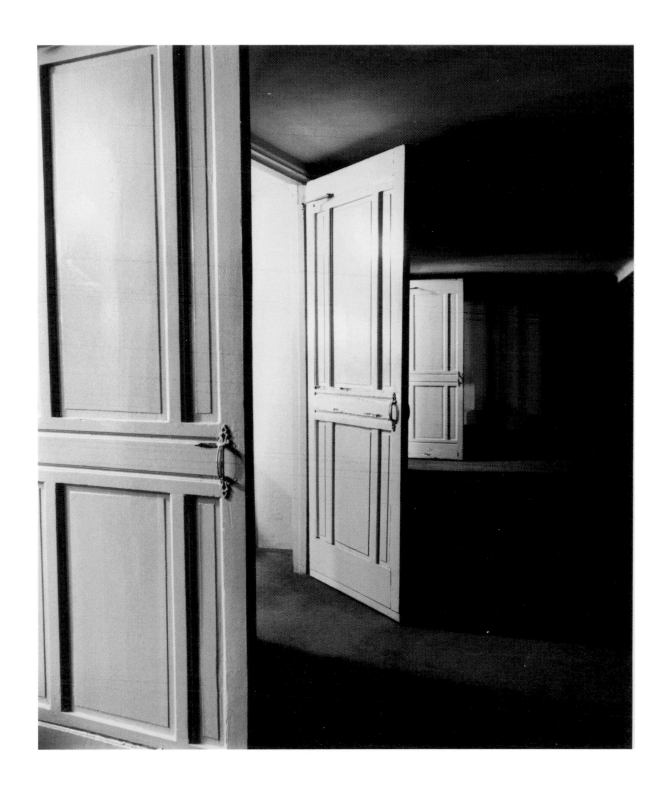

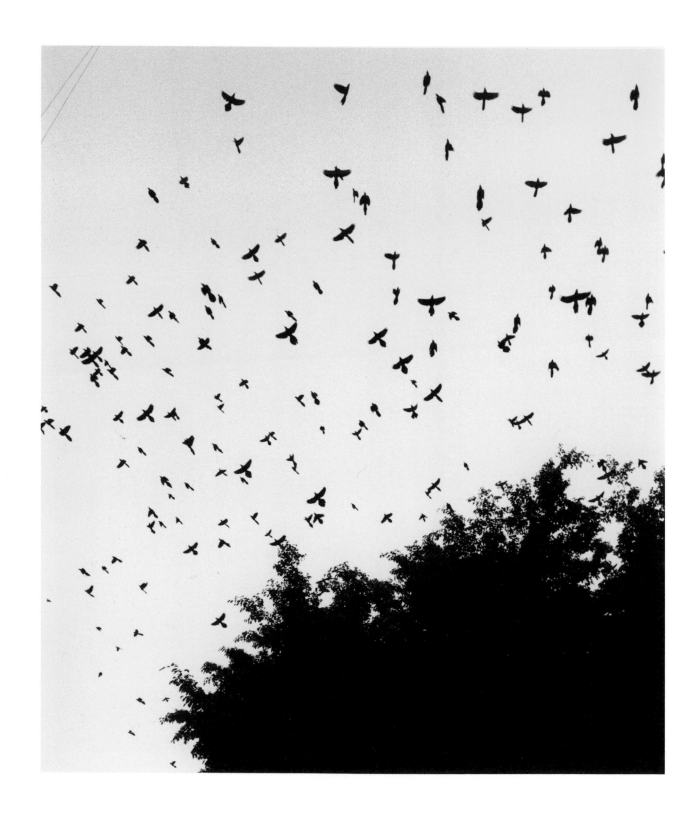

CACOPHONY OF BIRDS
Campeche, 2001

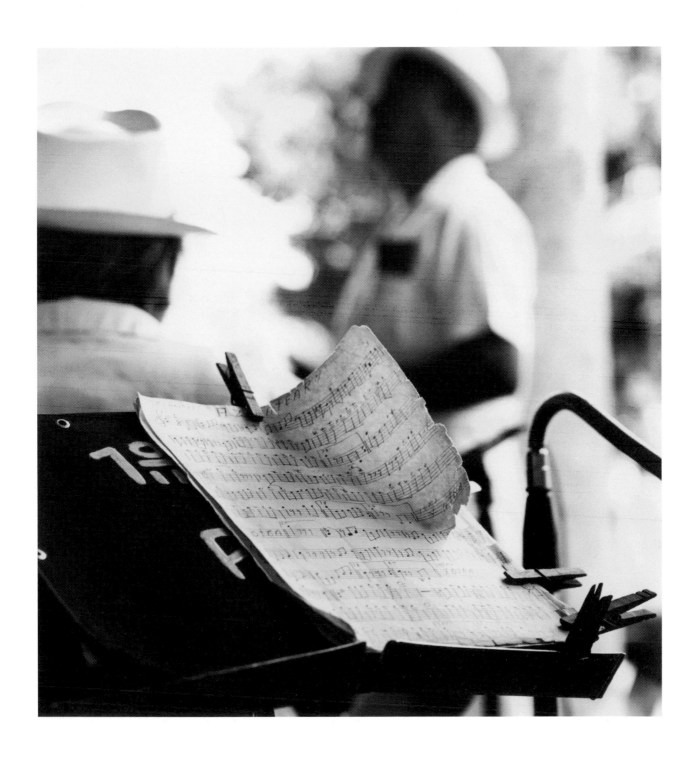

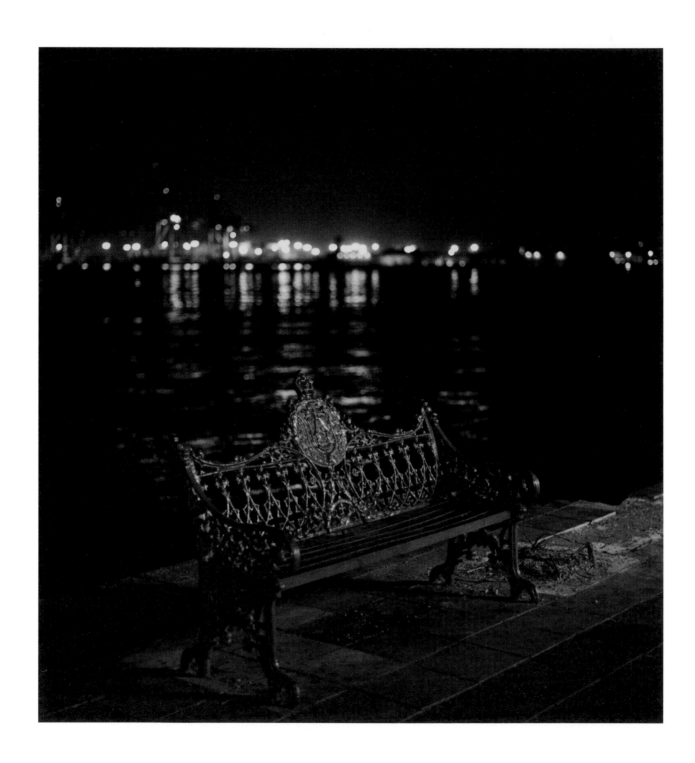

12 | HARBOR BENCH
Veracruz, 1998

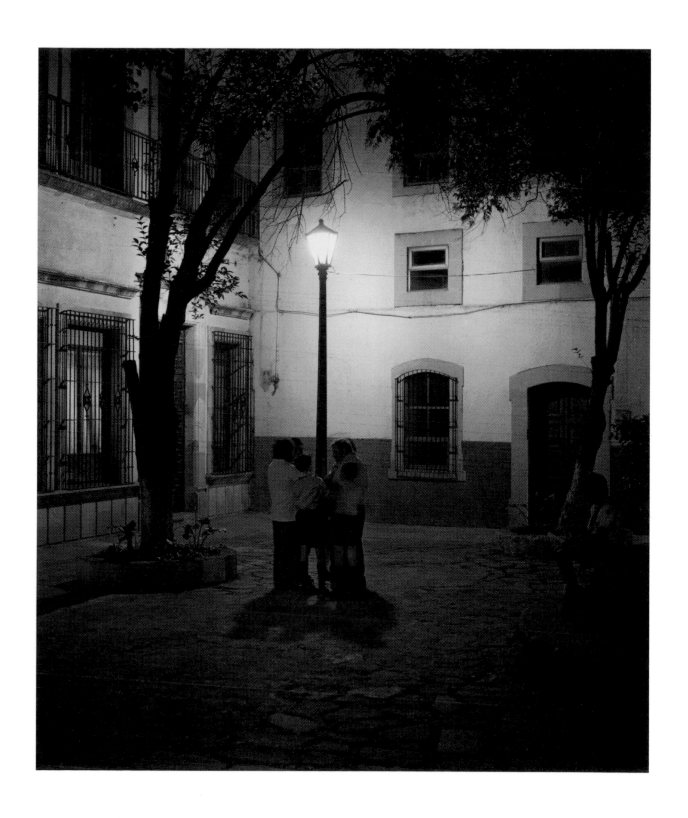

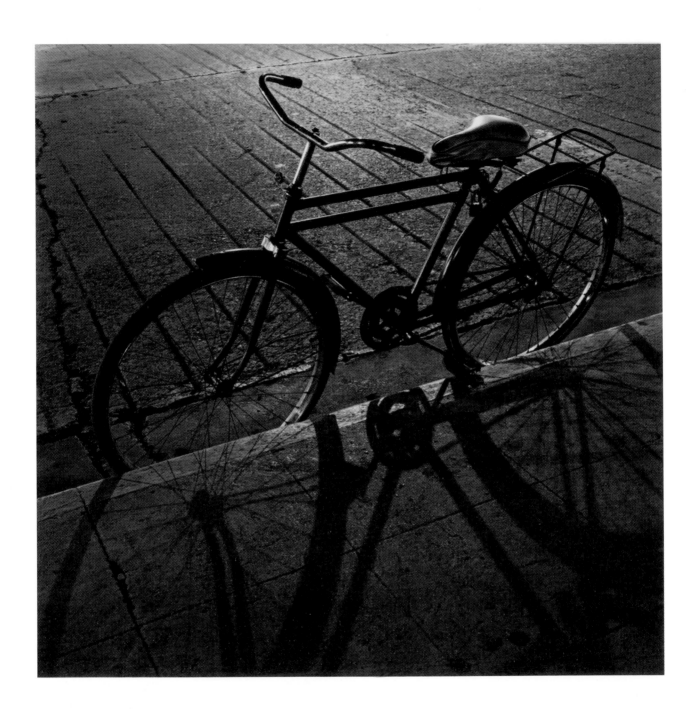

14 | BIKE SHADOW
Motul, 2001

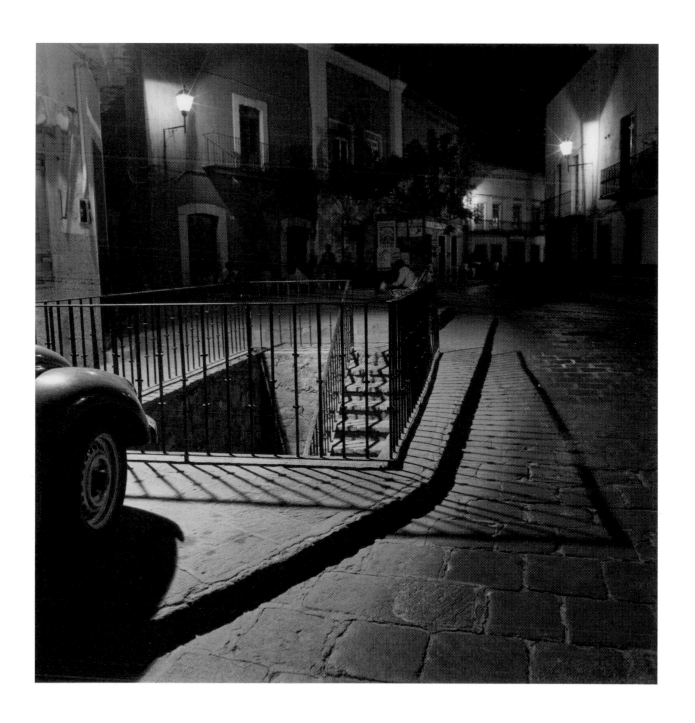

16 | Shadow of the Fiesta
Chiapa de Corzo, 2000

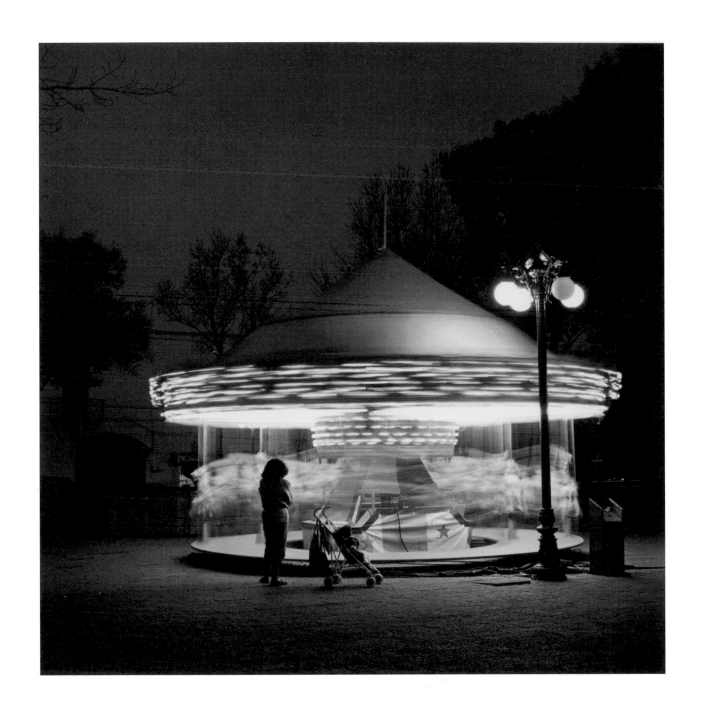

Tlaxcala, 1998

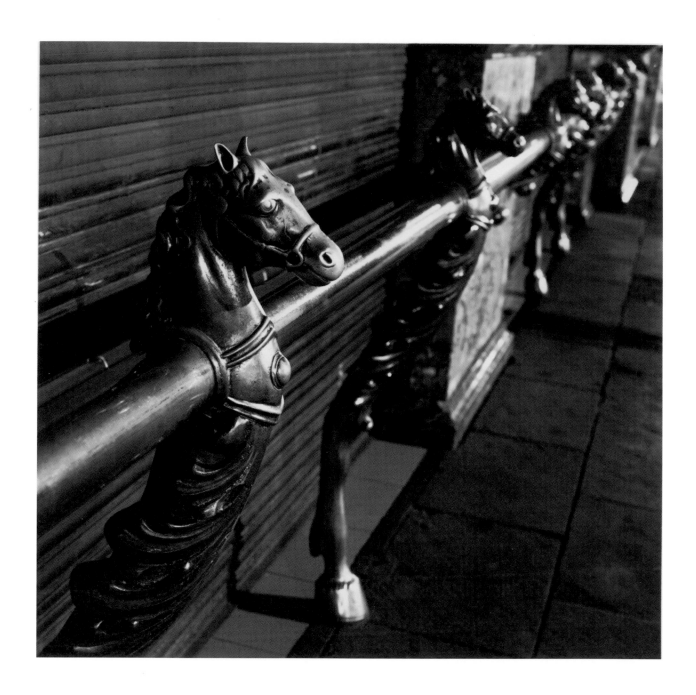

18 | HORSE RAIL
Mexico City, 2001

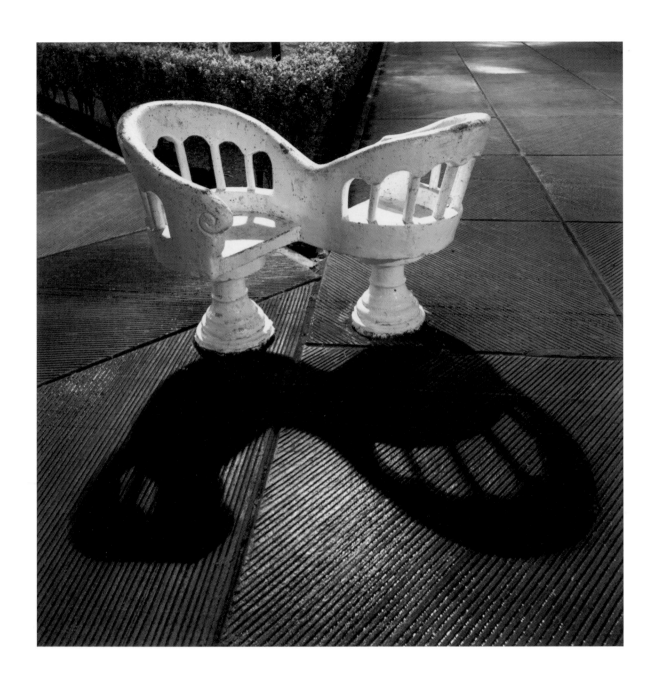

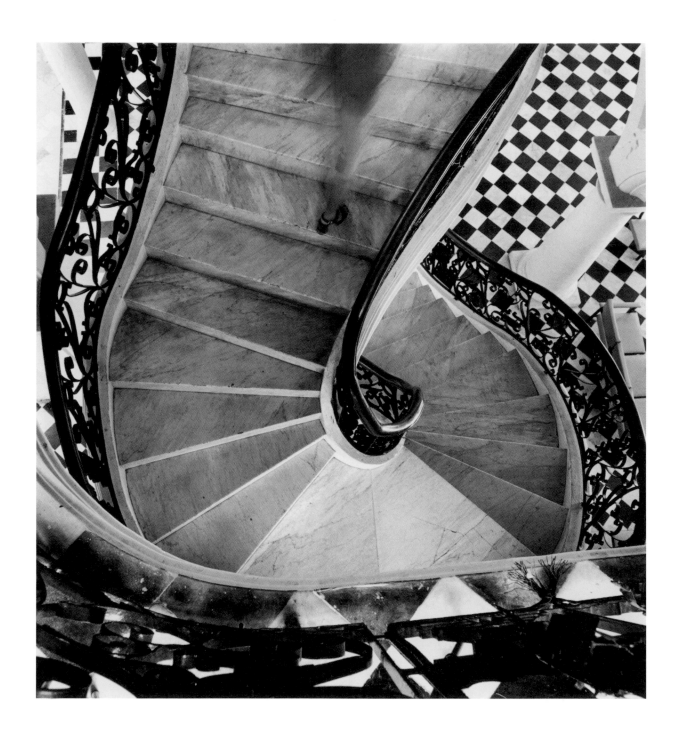

20 | CARVAJAL STAIRS
Campeche, 2001

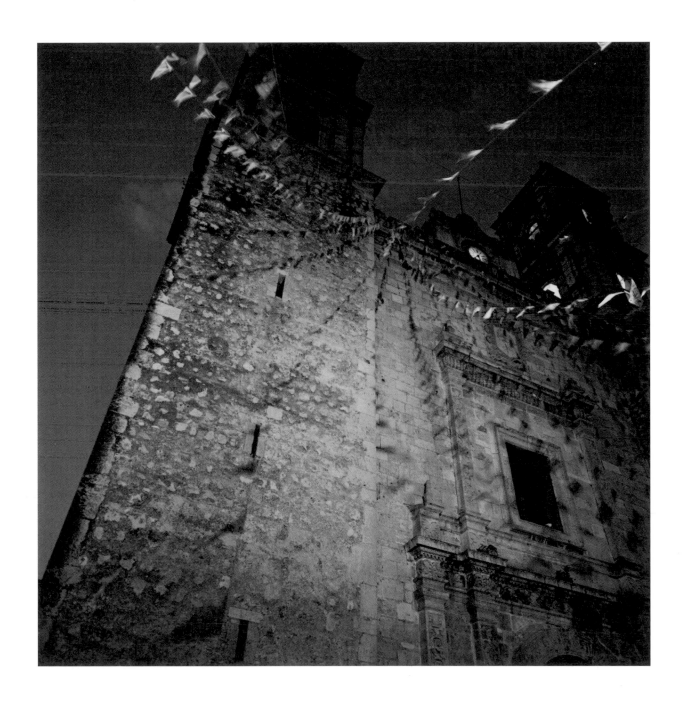

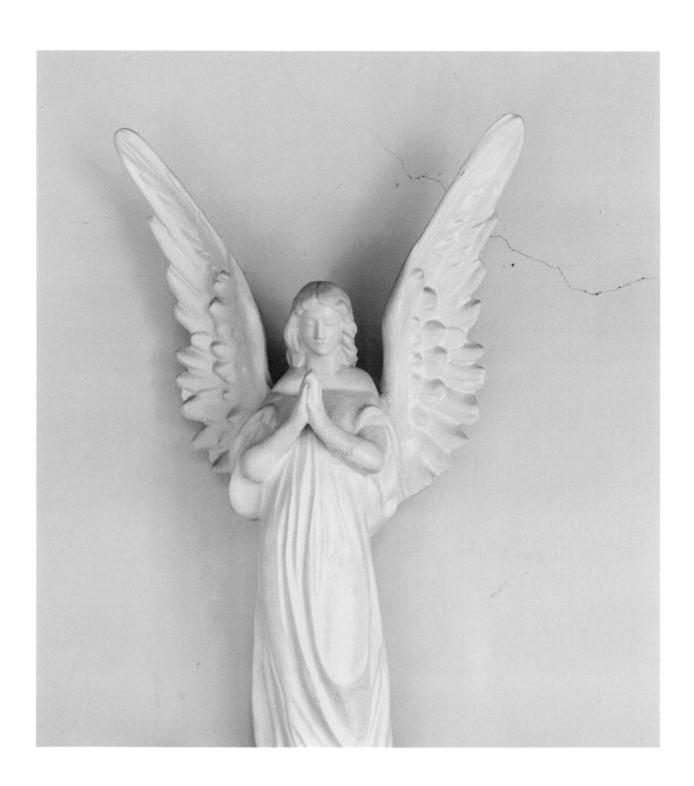

22 | ANGEL
Guanajuato, 1997

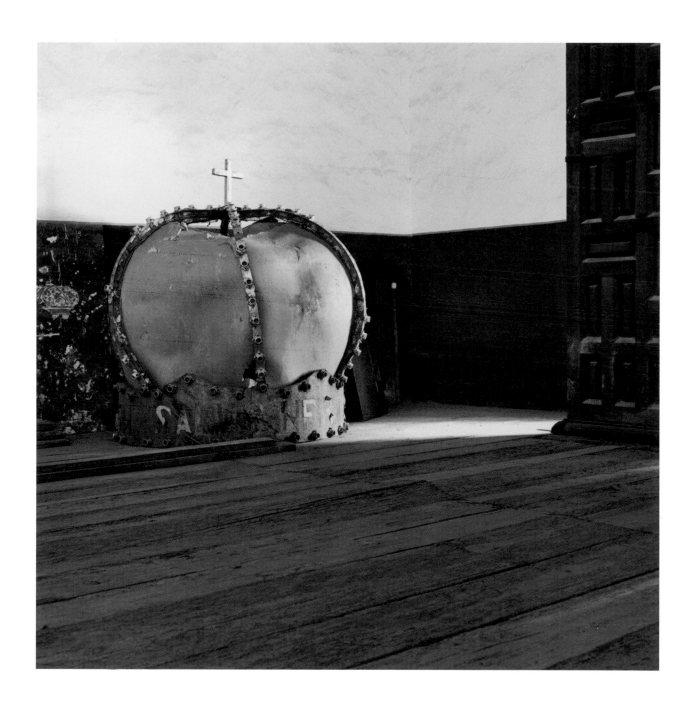

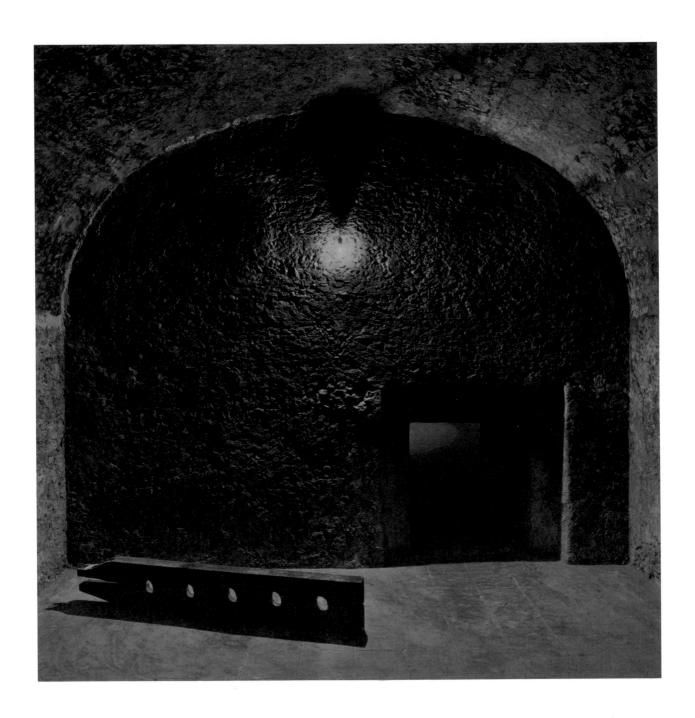

24 | DUNGEON
Campeche, 2001

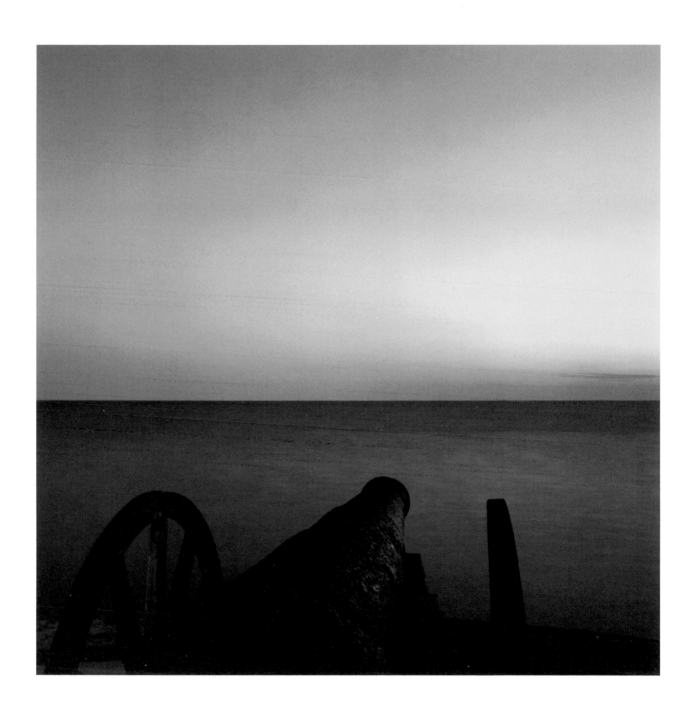

EASTERN CANNON | 25
Campeche, 2001

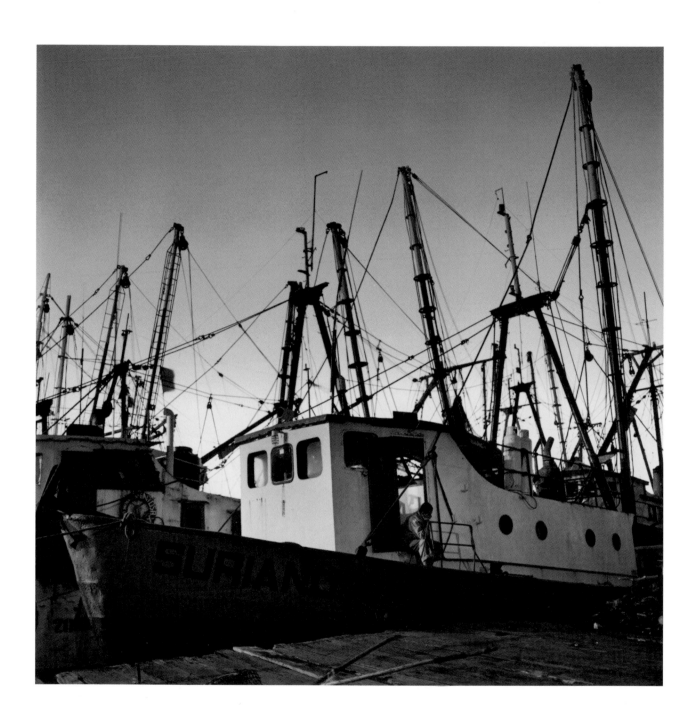

26 | MAQROLL AT REST
Salina Cruz, 2000

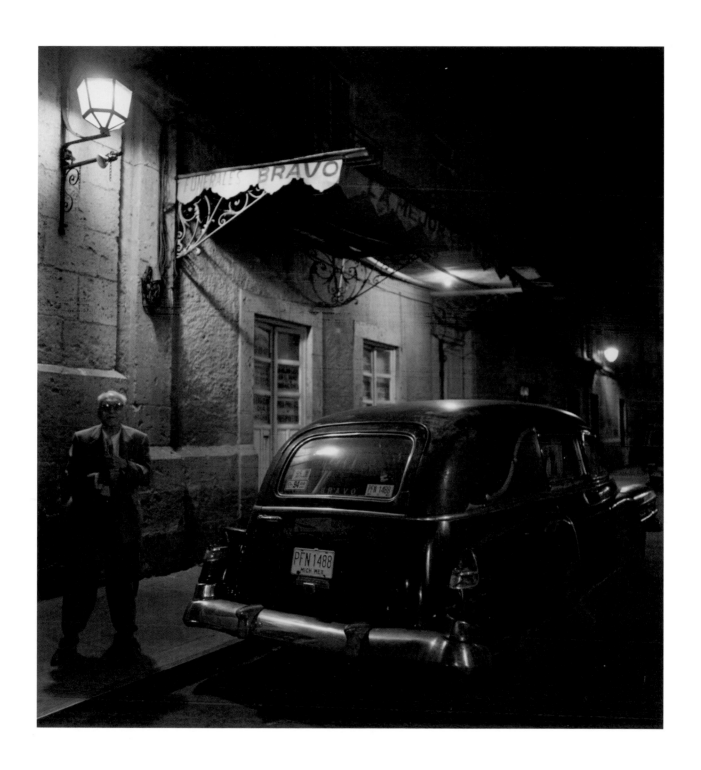

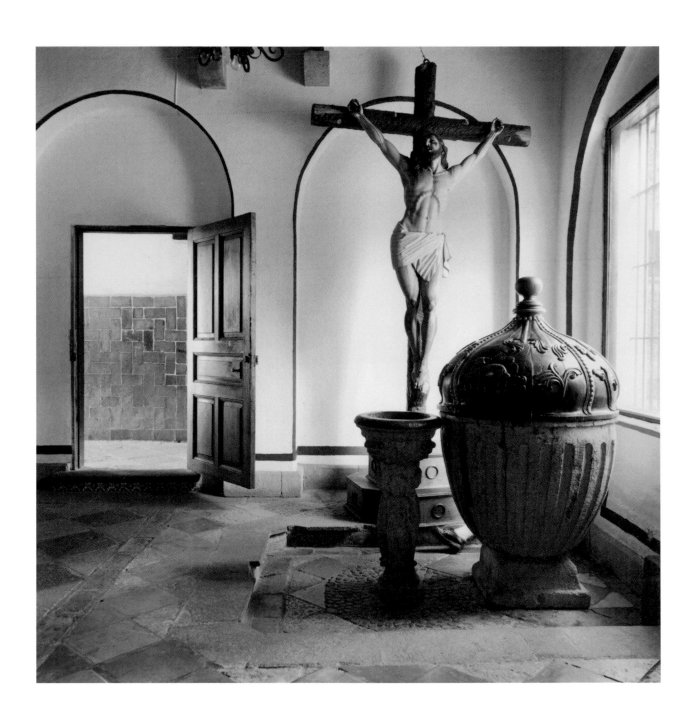

CHRIST AND DEVOTEE
Mexico City, 2001

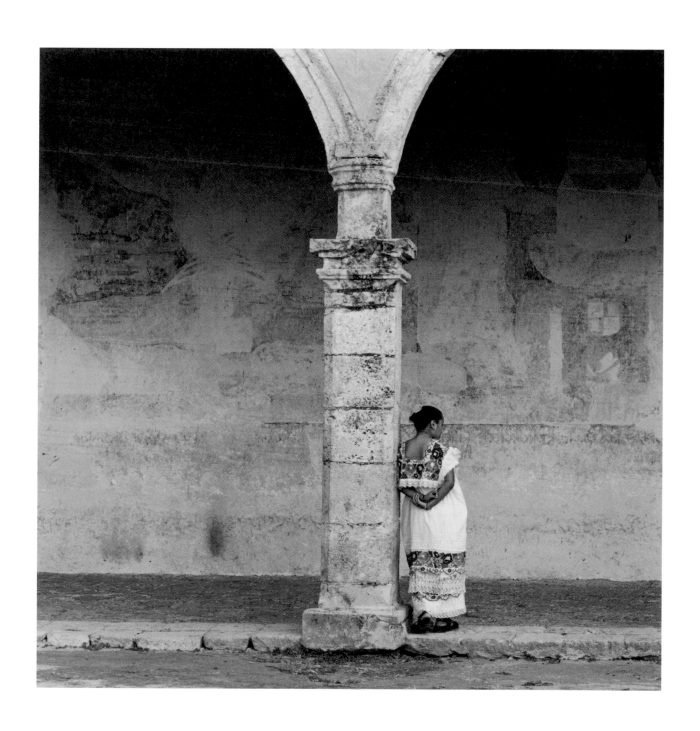

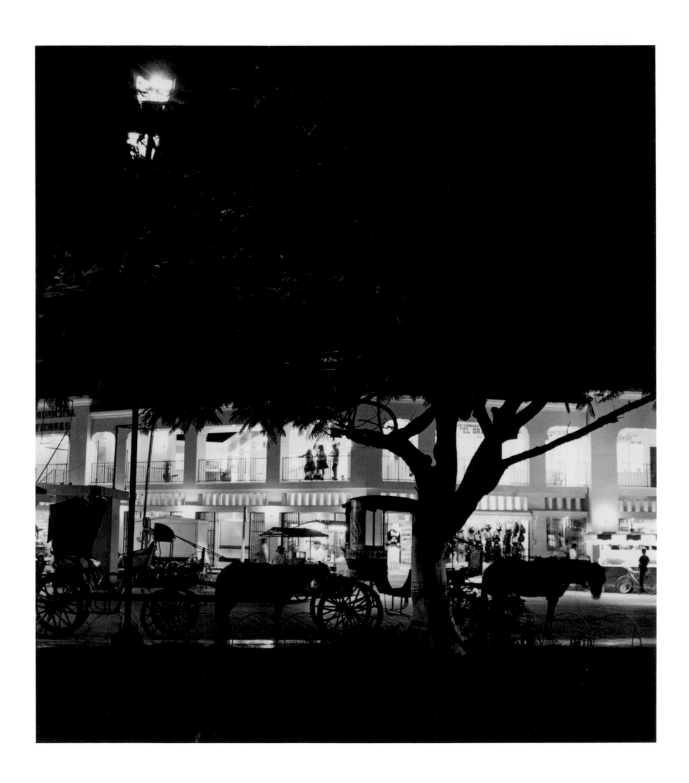

SCHOOLGIRLS
Motul, 2001

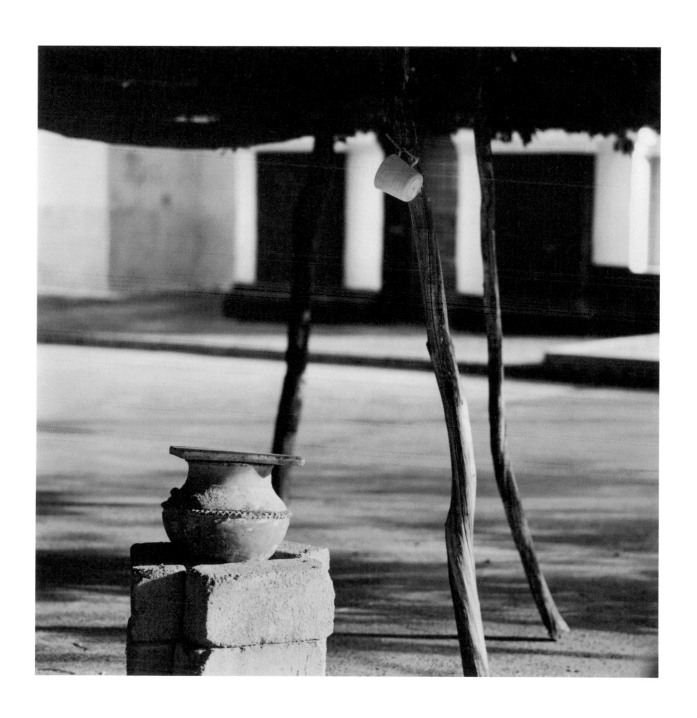

WATER JUG (WITH MEMORIES OF GABRIEL GARCÍA MÁRQUEZ) 31
Tehuantepec, 2000

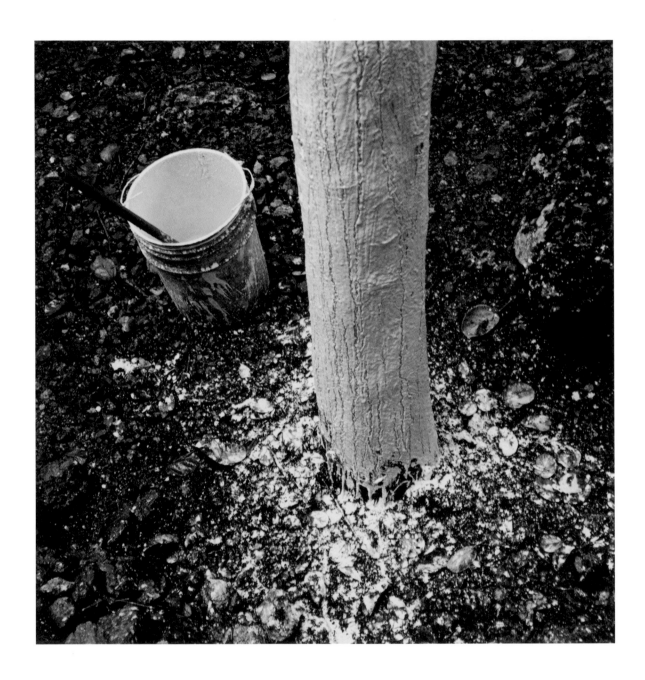

32 | PAINTED TREE
Valladolid, 2001

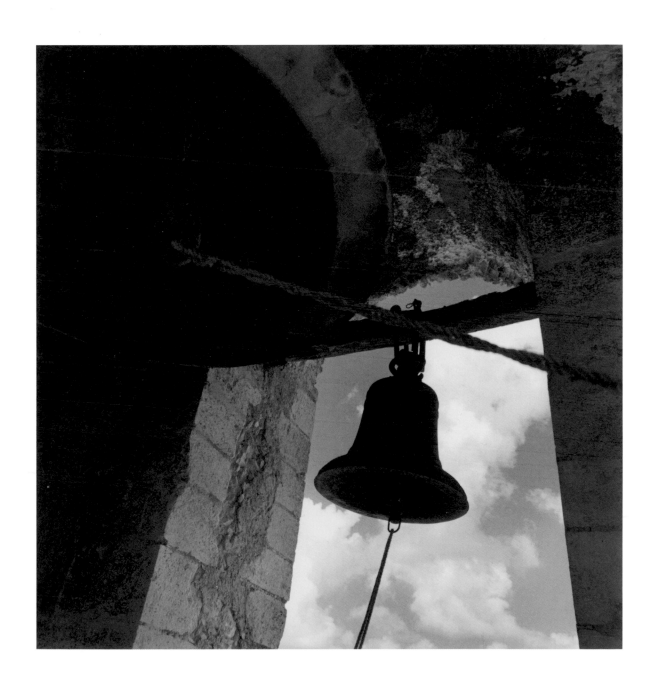

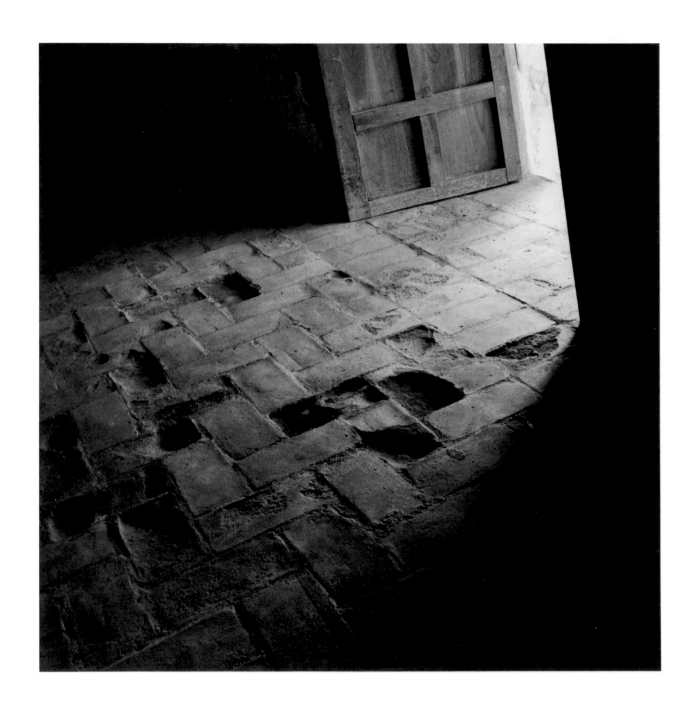

34 | ANCIENT FOOTPRINTS
Tehuantepec, 2000

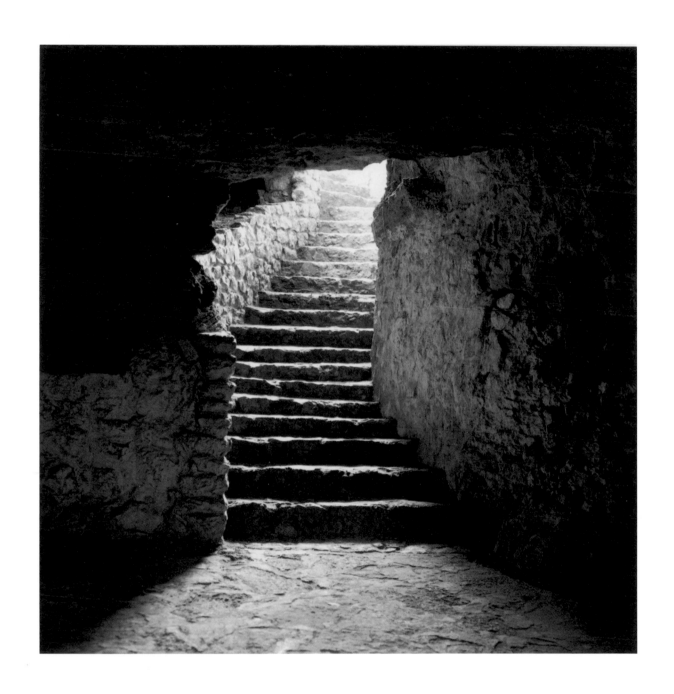

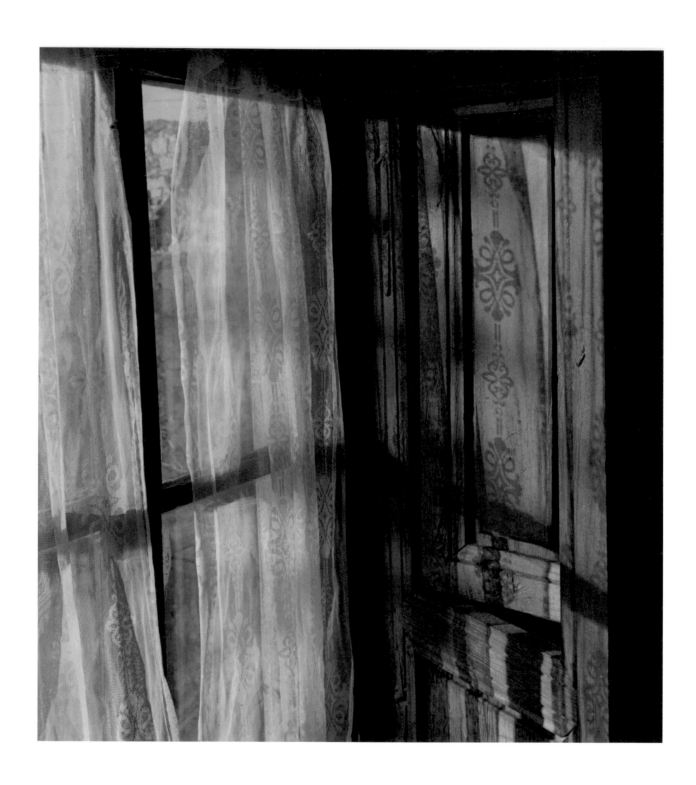

36 | Siesta
Real de Catorce, 1997

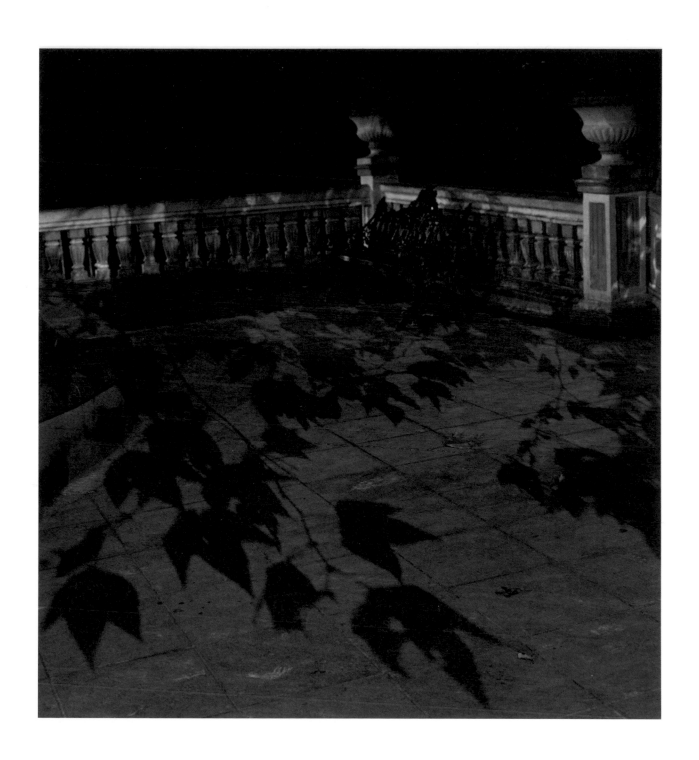

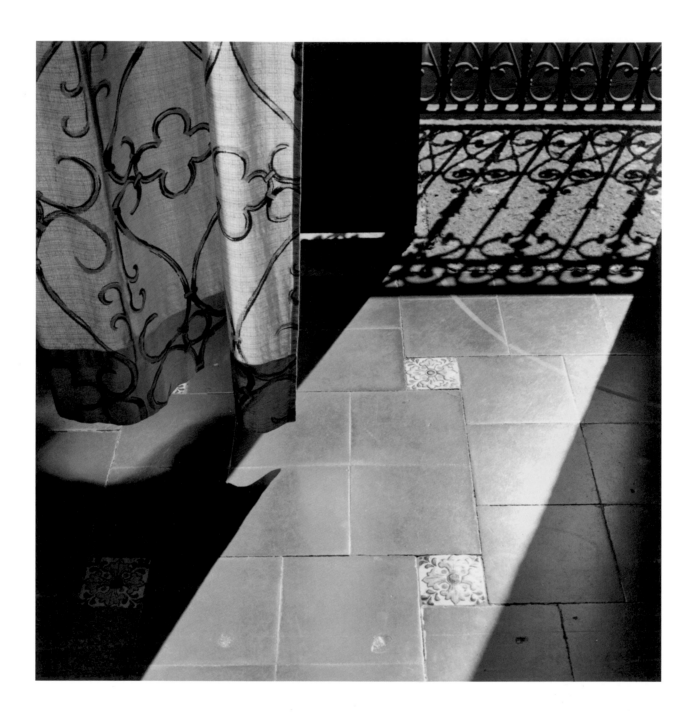

38 | SIESTA II
Puebla, 1998

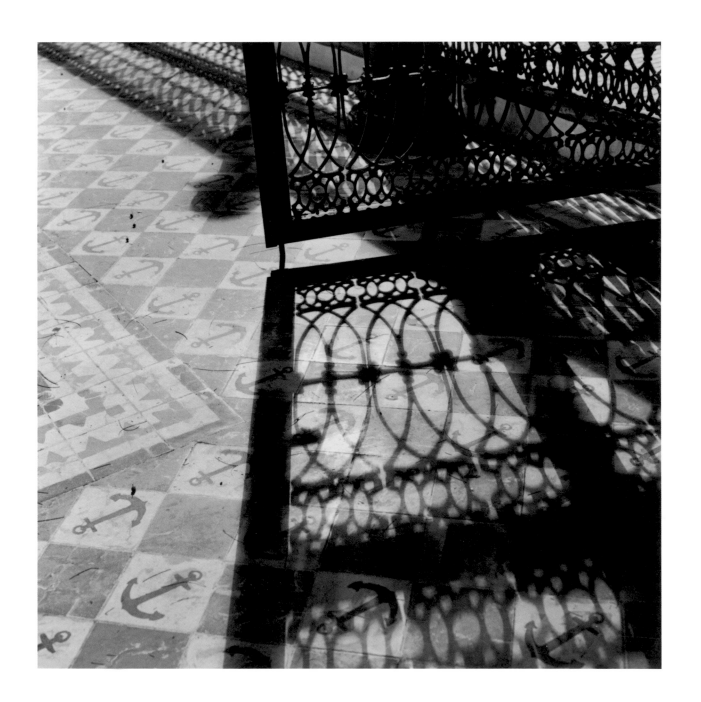

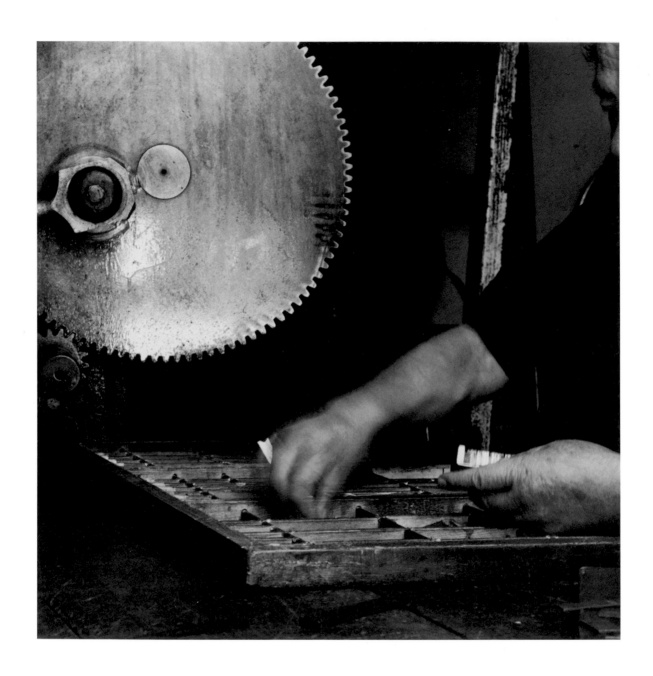

| Typesetter
San Cristóbal de las Casas, 2000

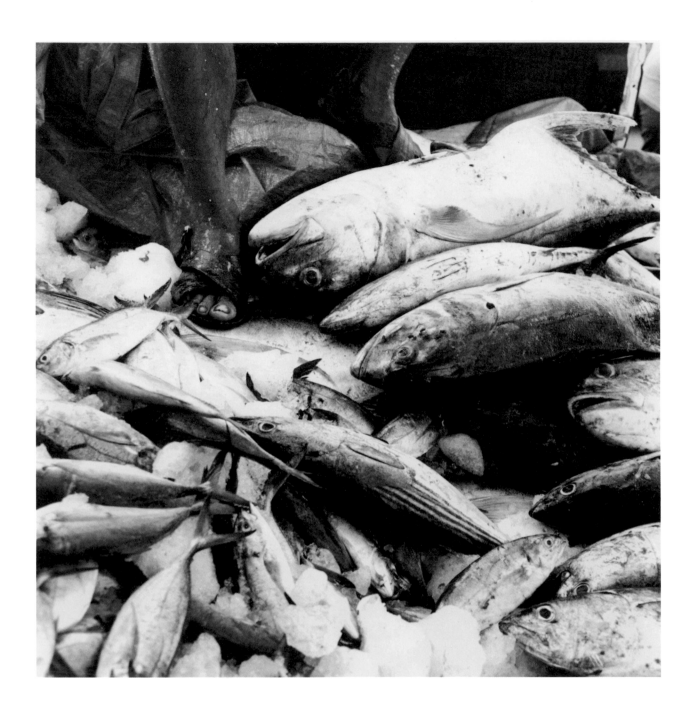

Salina Cruz, 2000

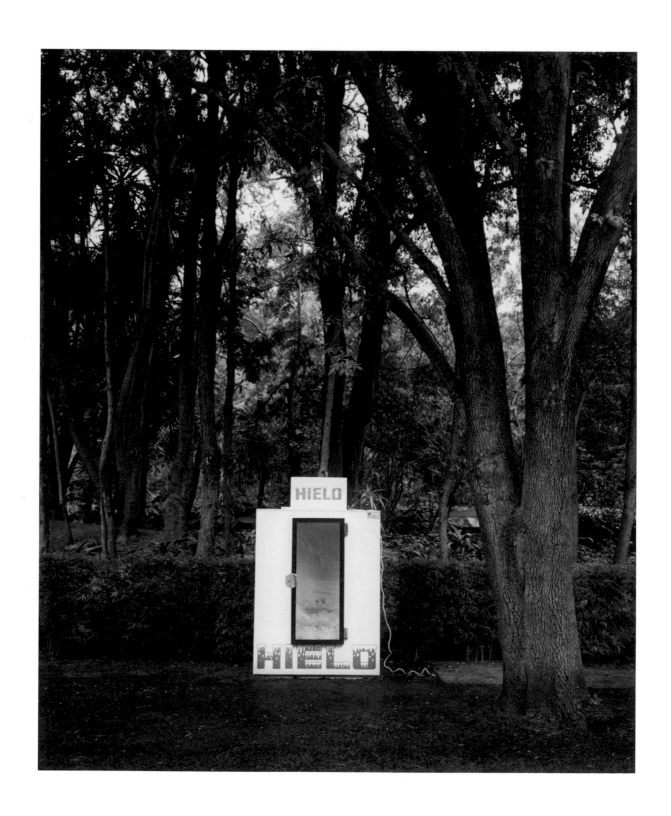

42 | HIELO
Guanajuato, 1997

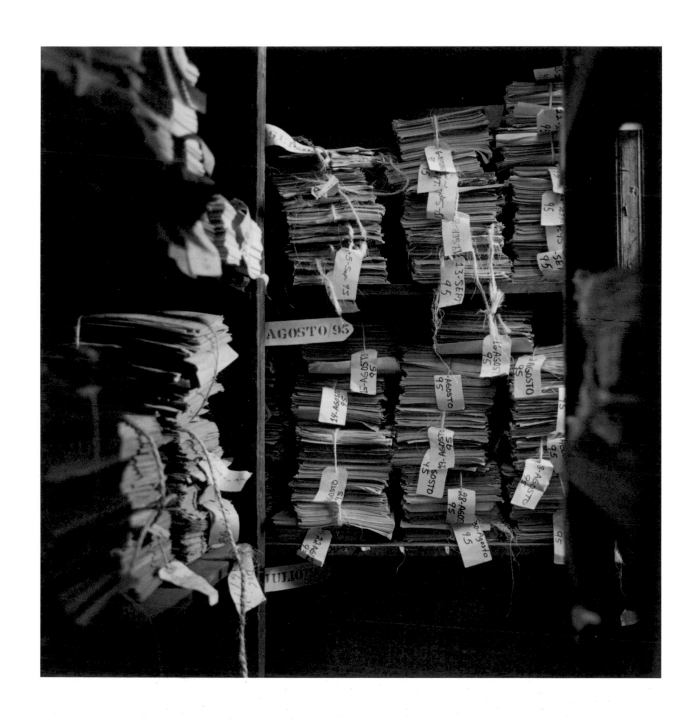

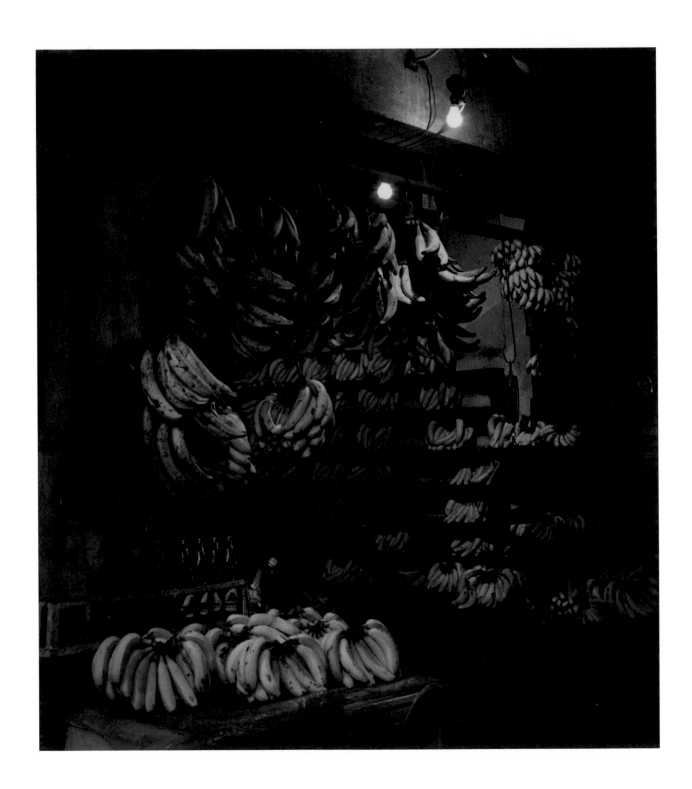

44 | BANANAS
Veracruz, 1998

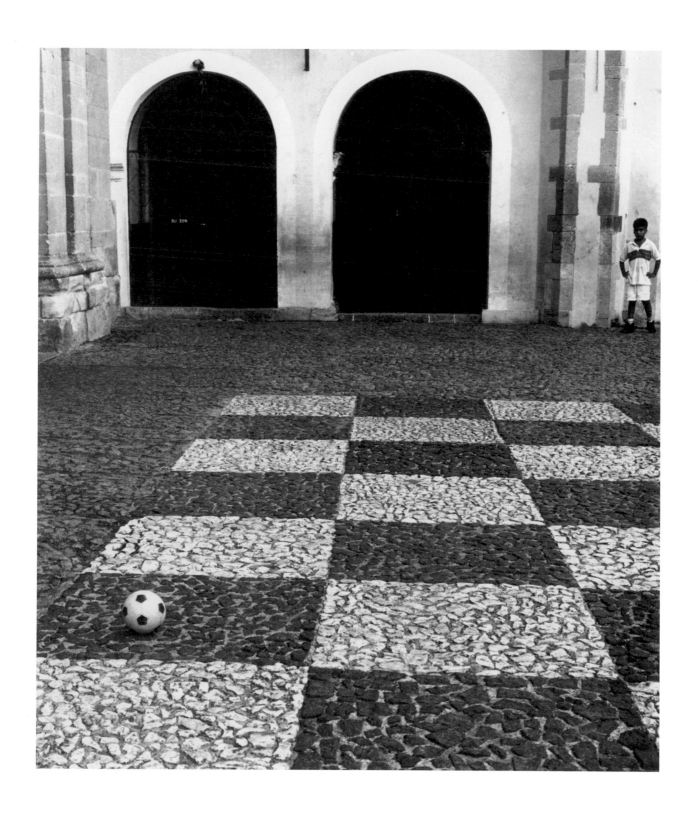

Taxco, 1998

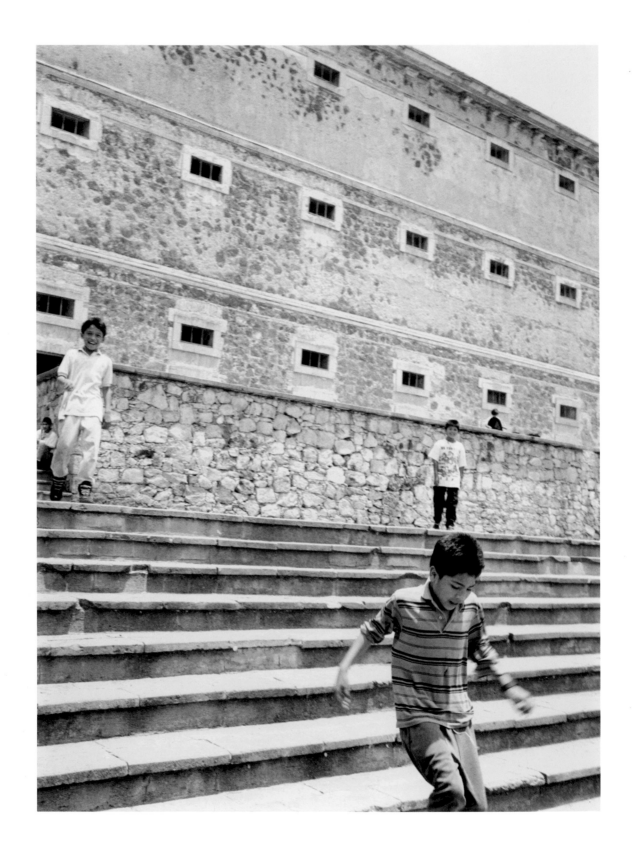

46 | ALHÓNDIGA DE GRANADITAS
Guanajuato, 1996

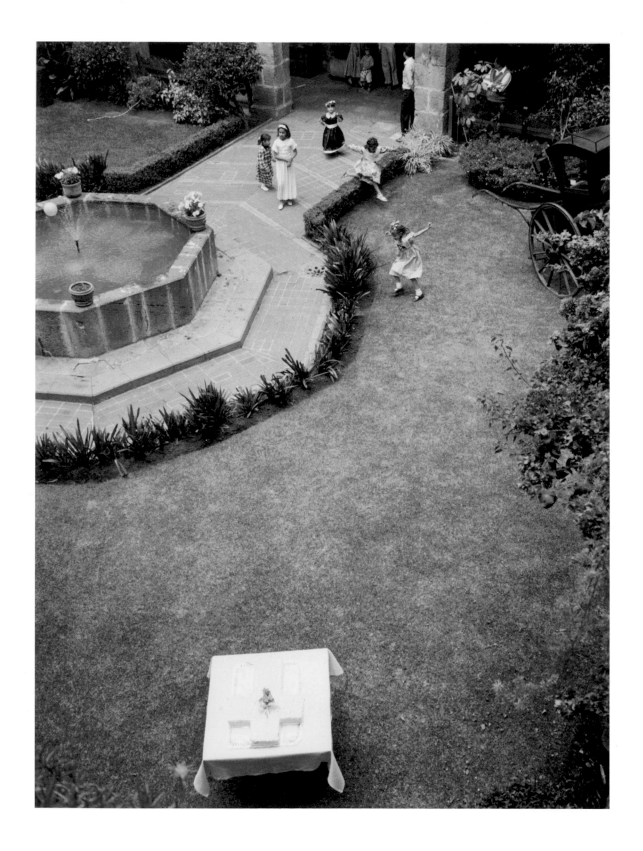

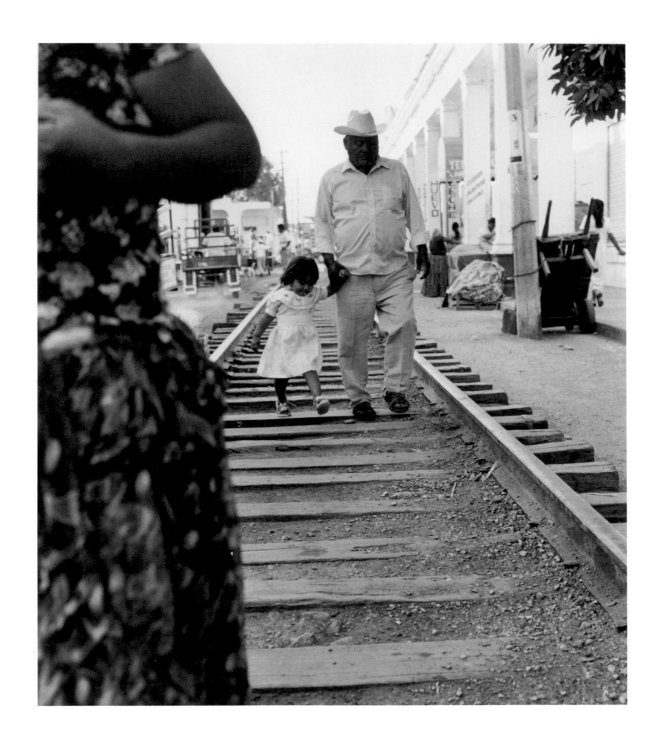

WALKING THE TRACKS
Tehuantepec, 2000

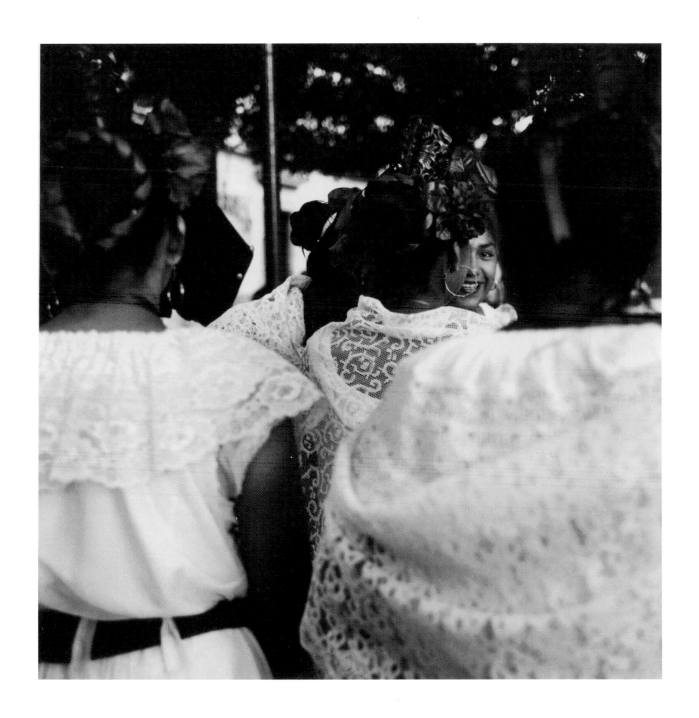

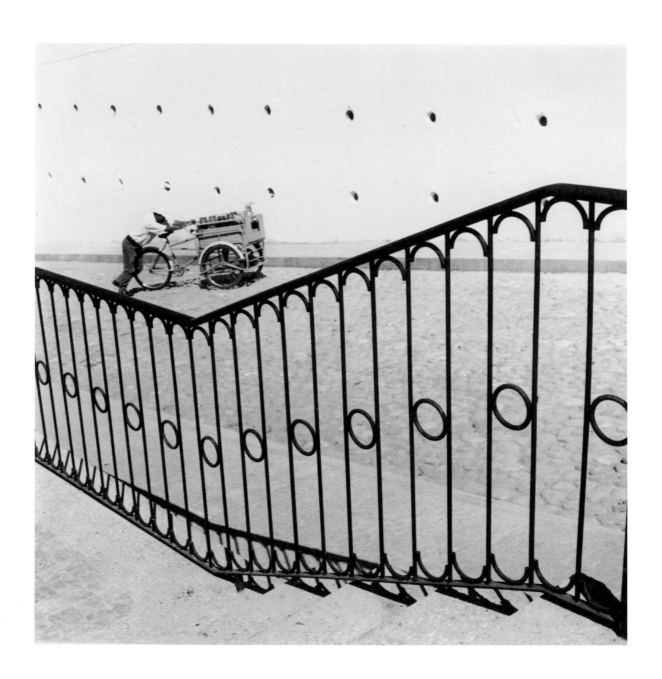

| SHAVE-ICE VENDOR
Chiapa de Corzo, 2000

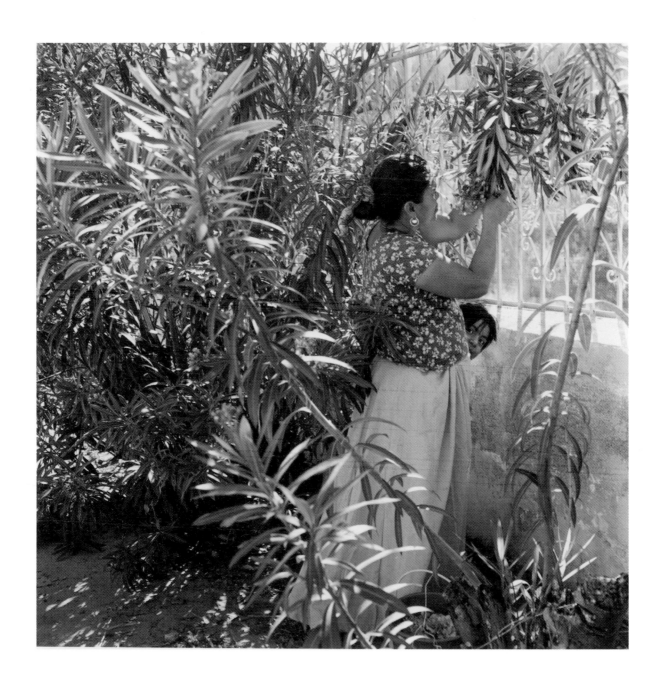

Tehuantepec, 2000

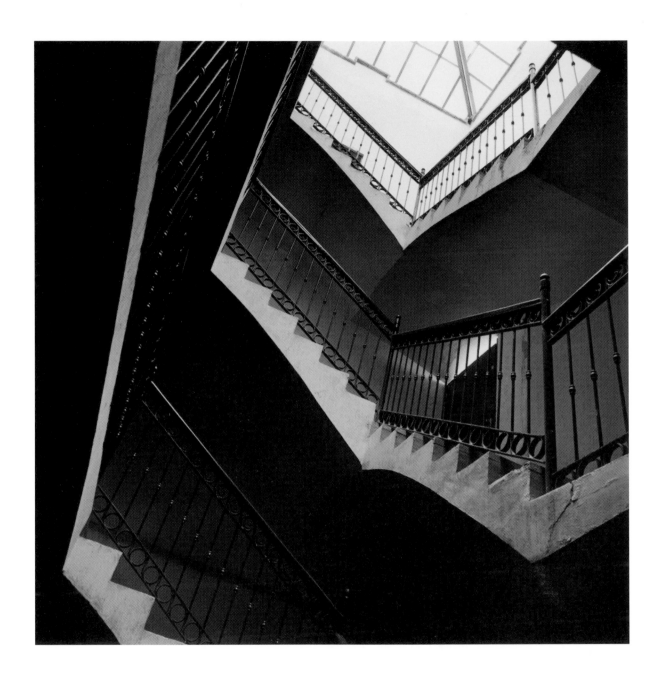

52 | THEATRE STAIRS
Oaxaca, 2000

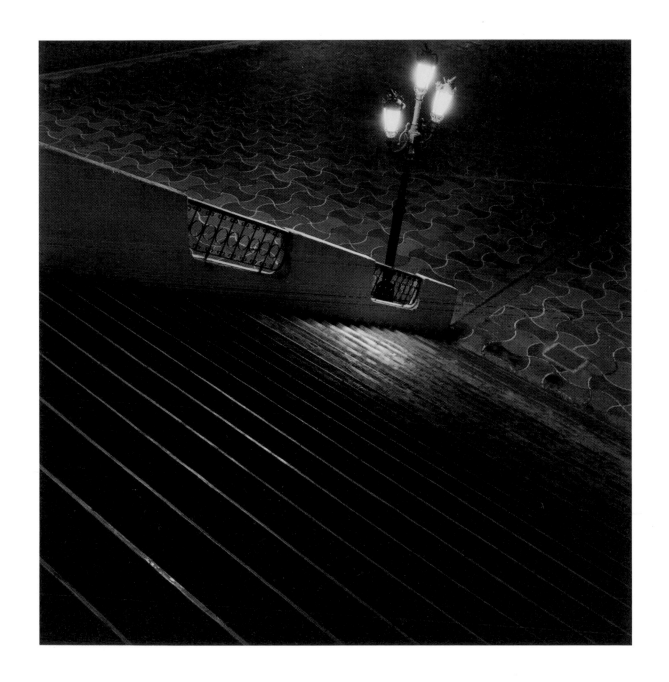

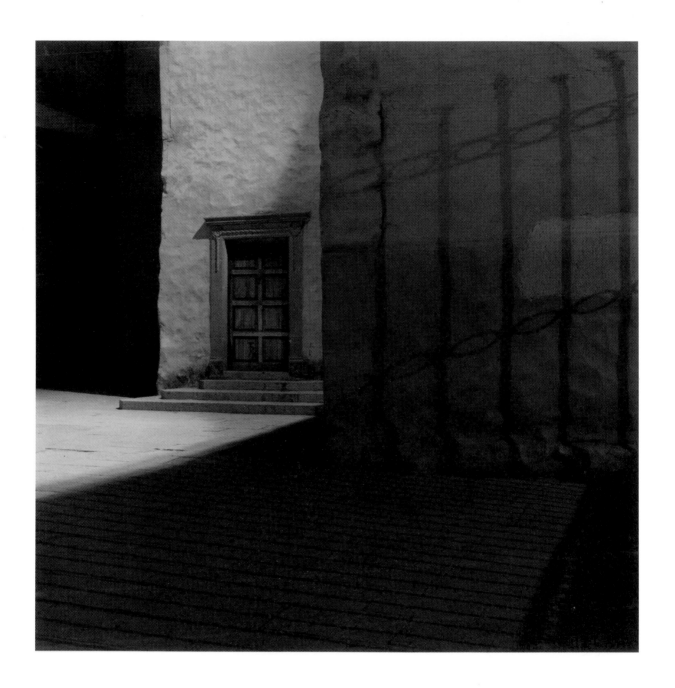

COLONIAL NOIR
San Luis Potosí, 1998

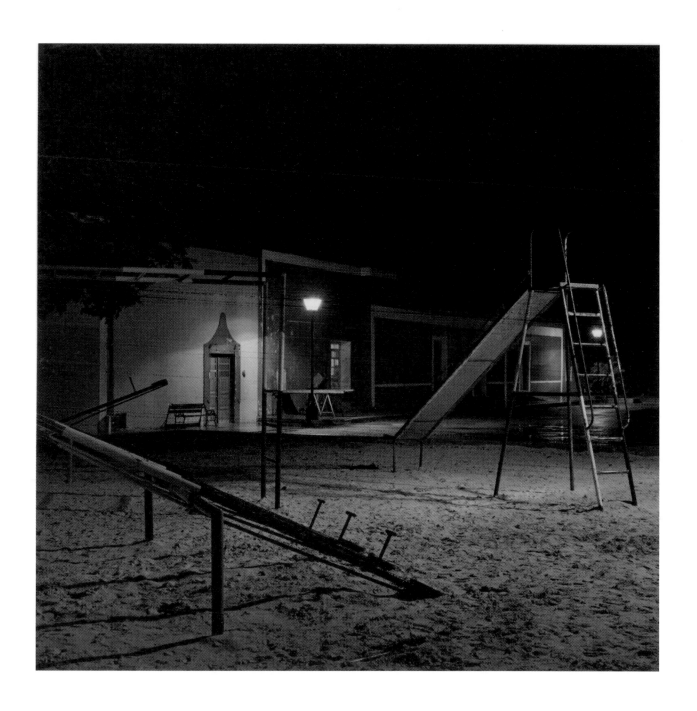

PLAYGROUND | 55
Valladolid, 2001

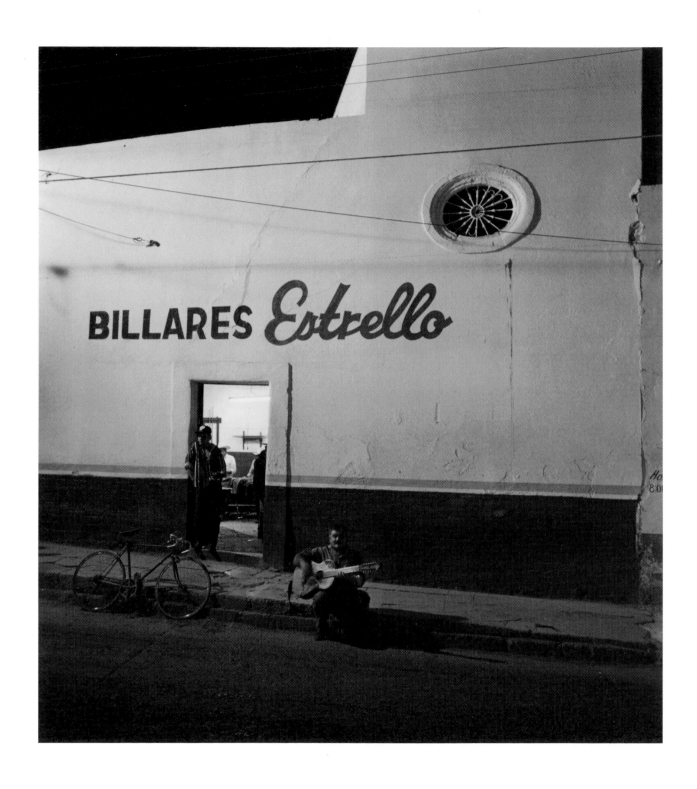

56 | BILLARES ESTRELLO
Matahuela, 1997

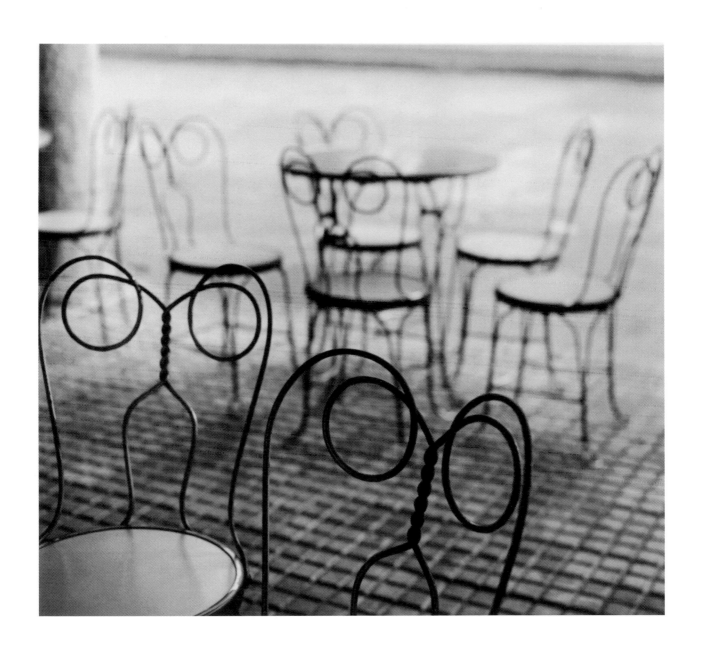

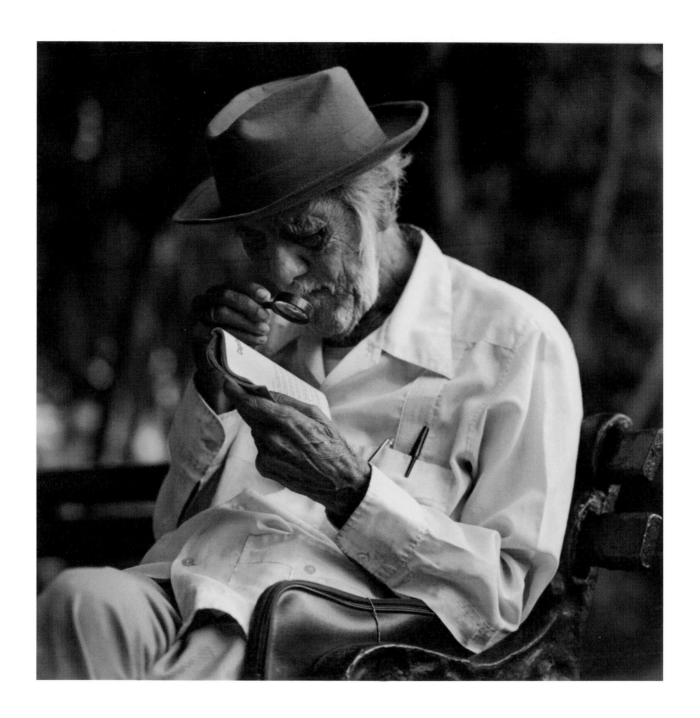

Reader
Mérida, 2001

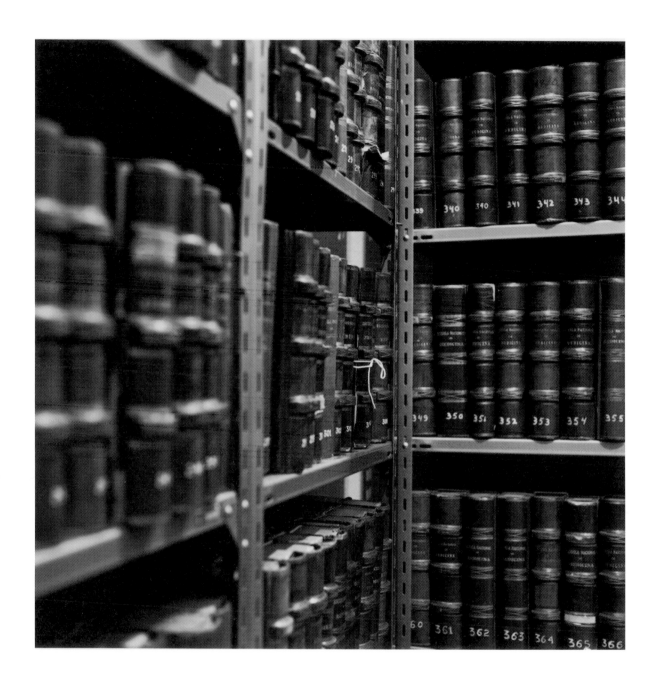

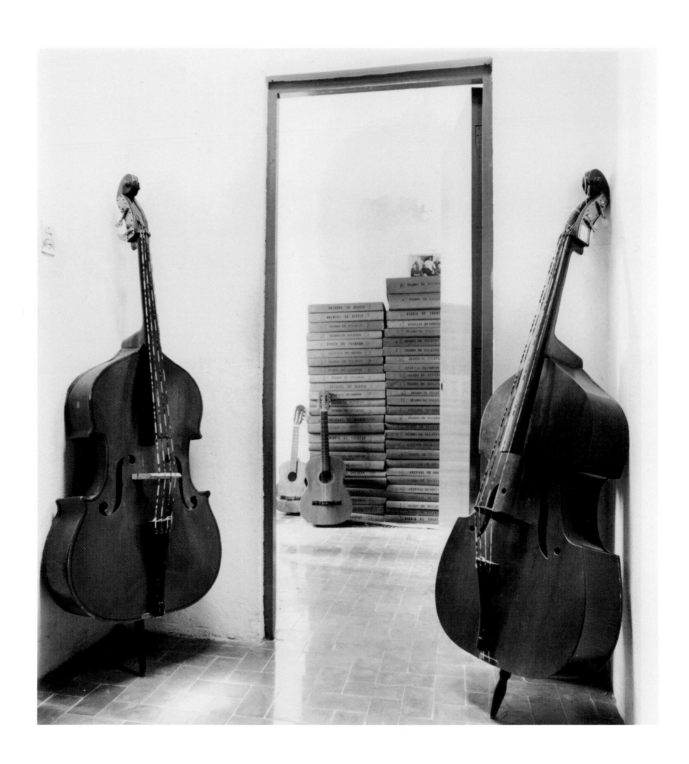

Two Cellos
Motul, 2001

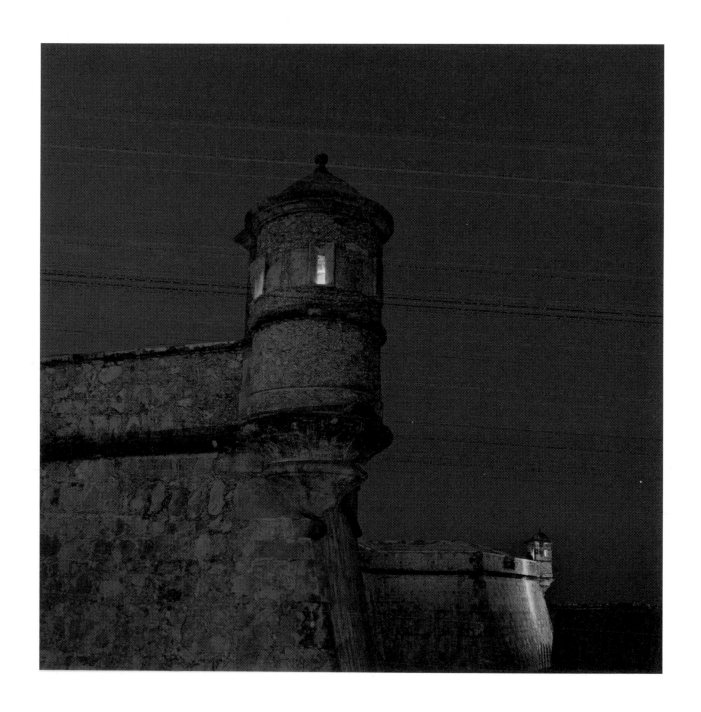

Campeche, 2001

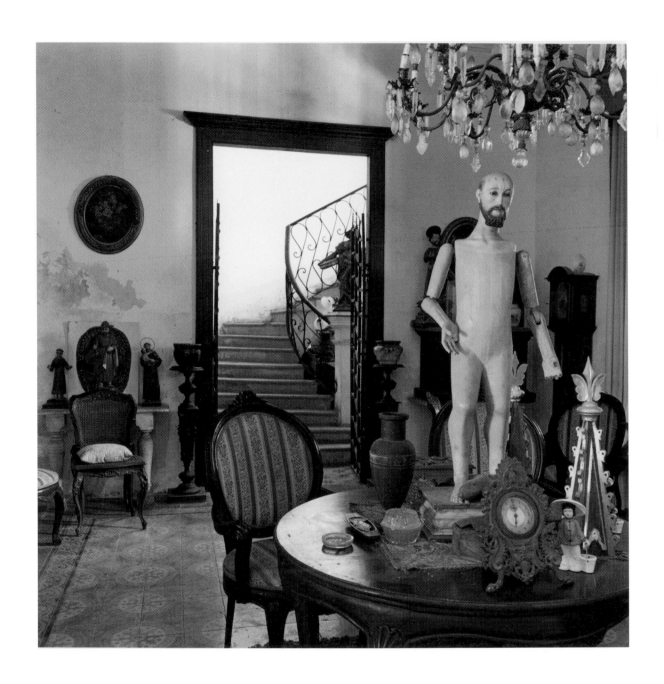

| Pinocchio
Mérida, 2001

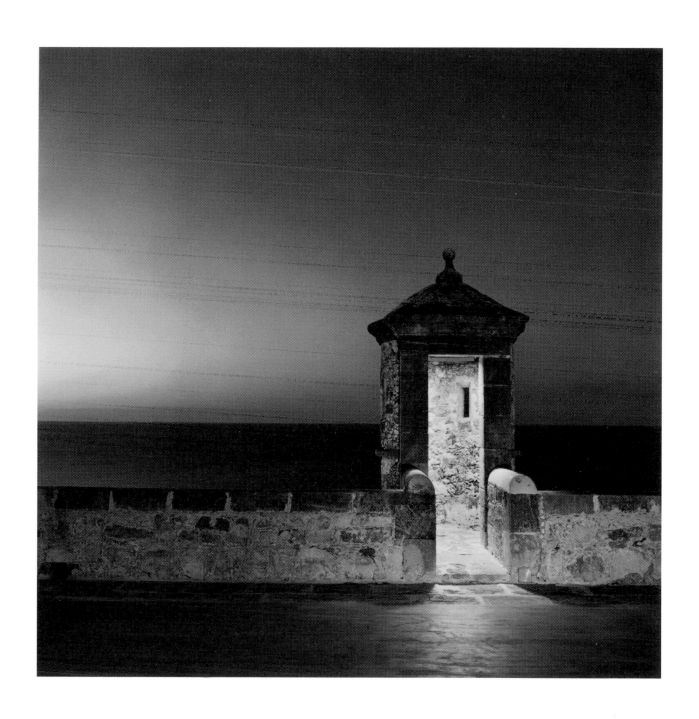

Campeche, 2001

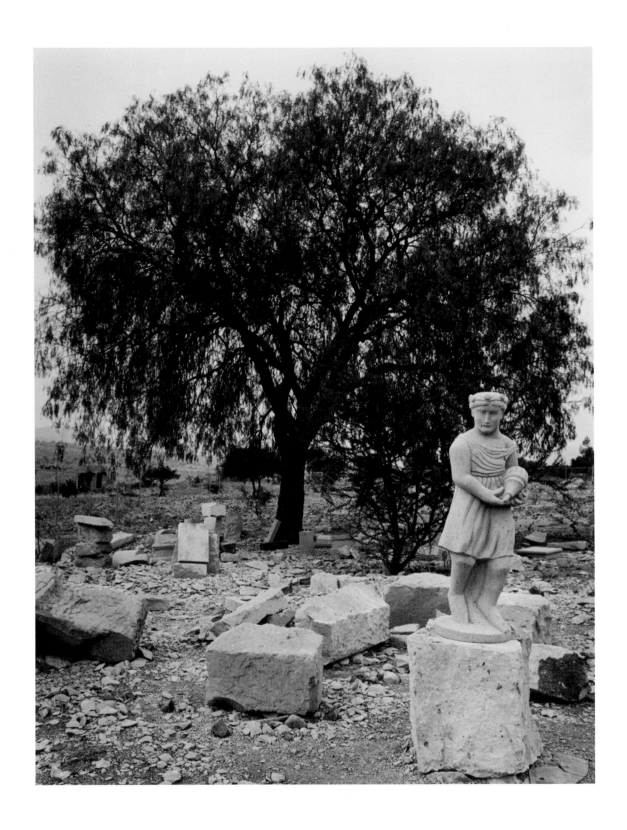

64 | STONE CUTTERS COMPOSITION II
Guanajuato/San Miguel de Allende, 1997

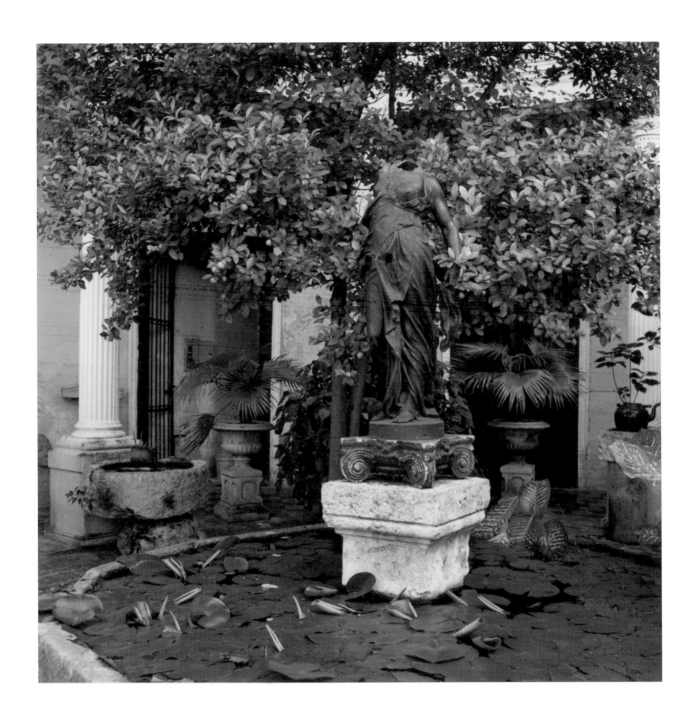

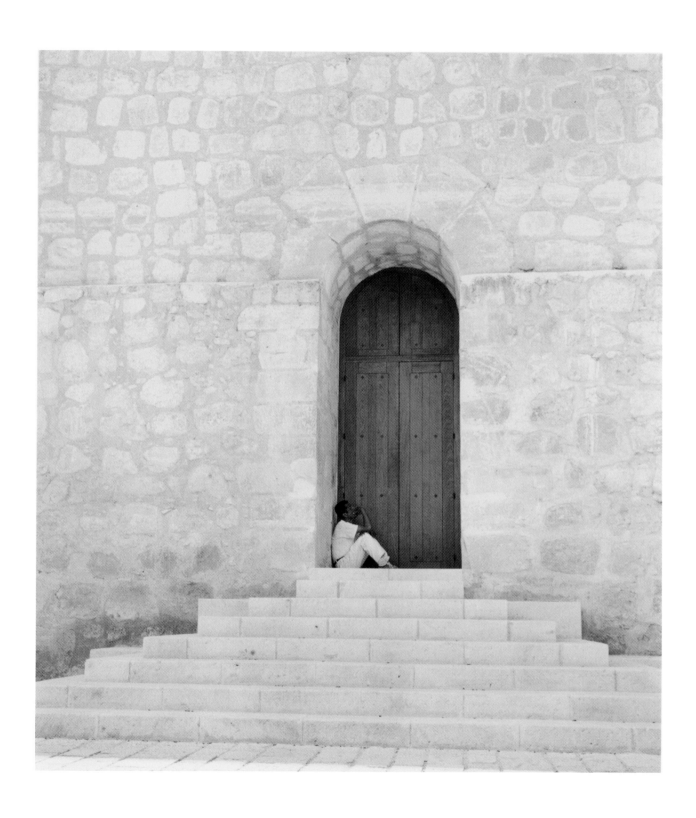

66 | RESTING IN THE DOORWAY
Oaxaca, 2000

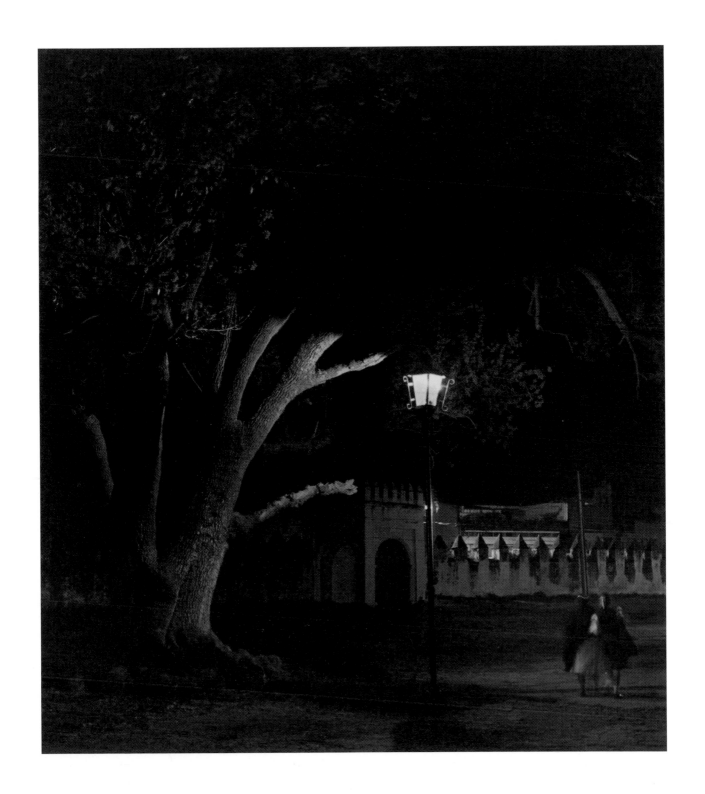

Cholula, 1998

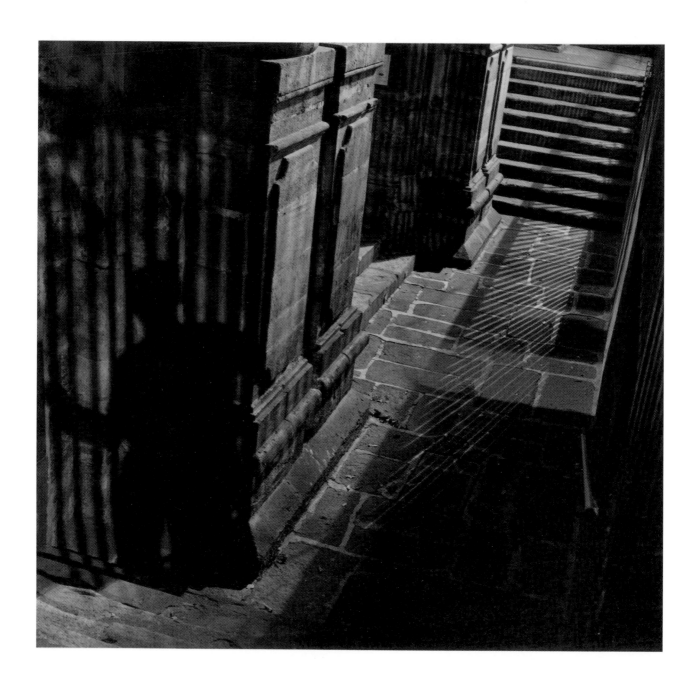

68 | ESCAPE
Mexico City, 1998

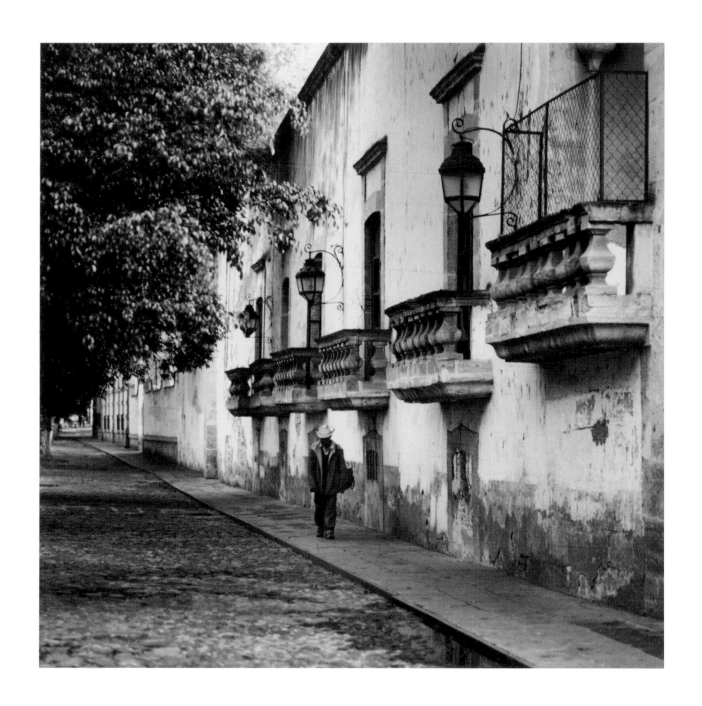

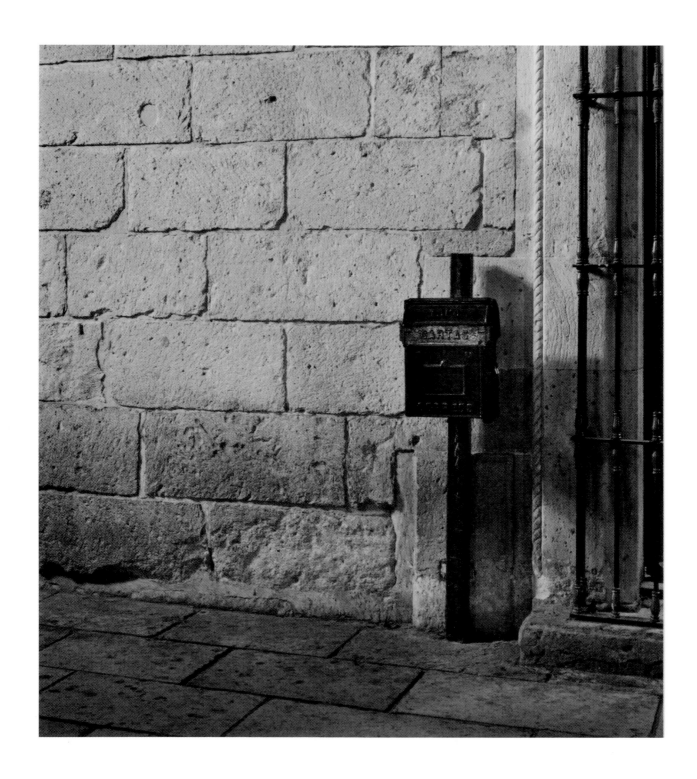

| CARTAS
Oaxaca, 2000

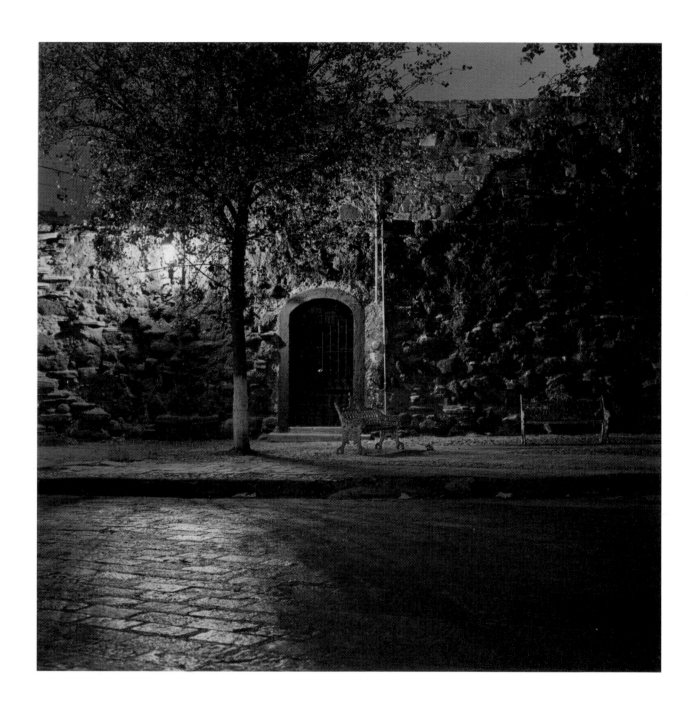

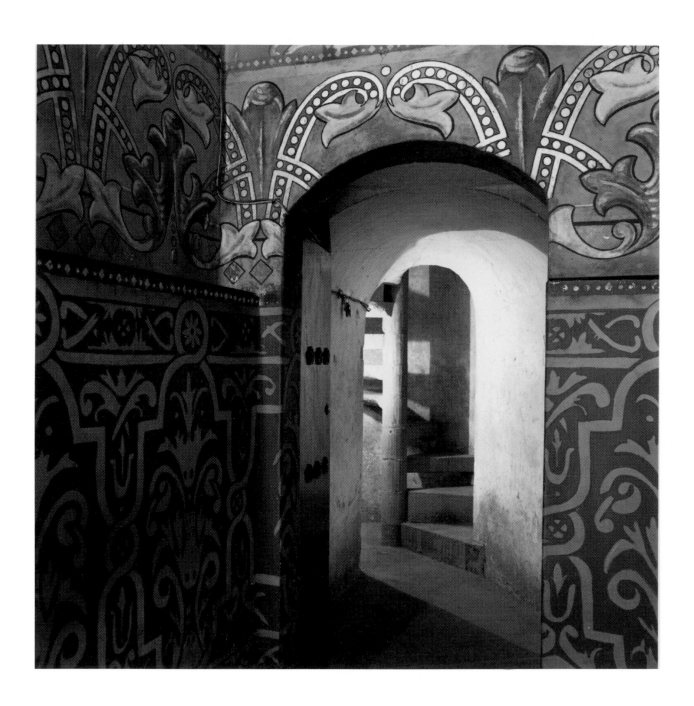

72 | Keys to the Tower
Mérida, 2001

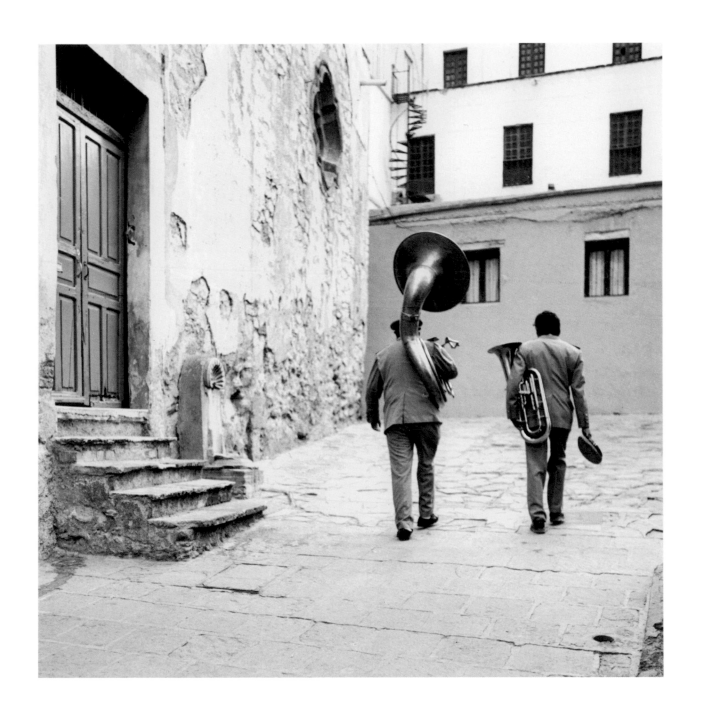

Notes on the Plates

The majority of the images were taken with the Hasselblad camera system using either a 501c/m or a 503c/w body; the remaining images were taken with a smaller, hand-held Fuji 645 camera. Some daytime images are hand-held, others and all nighttime images are taken with use of a small Gitzo tripod. Lenses are 50 mm, 60 mm, 80 mm, and 150 mm, and in some cases a Hasselblad Perspective Control Mutar was used. Films used include Ilford HP5 (developed in D76 or C76), Kodak T-Max 100 (developed in Agfa Rodinal), and Fuji 100 ("Sumatra Rain" only). All prints are made with Forte Polywarmtone or Polygrade semi-matte paper and are selenium-toned.

Sumatra Rain, Sumatra, Indonesia, 1995 (frontispiece)

This photograph—taken during a rainstorm while overlooking a lake in Sumatra—was the impetus for starting the *Colonial Noir* series. Upon visiting a few sites in Indonesia, I was taken by the surrealism of colonial architecture, in relation to both its environment and itself; the noir aspect of the work did not became prominent until later, in Mexico.

1. *Eleventh Courtyard*, Pátzcuaro, 1996

This is one of my favorite photographs in the series, and it is an important one in redefining my work as multidimensional. The print unites some of the more classical elements of documentary architectural photography with the decisive, aesthetic moment of Henri Cartier-Bresson and the Europeans.

2. *Night Watcher*, Morelia, 1996

I was deep in the shadows setting up for this shot when the young man came into the frame. After the first exposure he heard the camera and thought I wanted him to move. I motioned for him to stay, at which point we both went about our business, photographing and dreaming.

3. *Night Fountain*, Morelia, 1996

Photographed at dawn during my first trip for this series. Photographing night scenes using street light is often best when there is just a touch of light in the sky to give the world a small amount of additional texture. The reflecting fountain has a hint of Lewis Carroll.

4. *Rook*, Cholula, 1998

This church, built around 1550, has the look of a walled fortress more than an inviting place of worship. I was drawn to the contrast between the sharp points of the protective wall and the soft clouds.

5. *Tower Eyes*, Campeche, 2001

In some ways this pays homage to Magritte: the architecture is a face, the clouds forming eyes without congruence. Technically, this is a demanding image to create and print, as the sky is considerably brighter than the tower's interior. The film was pulled two stops and developed in a very dilute solution.

6. *Open Hands*, Morelia, 1996

Using the 150 mm lens and a shallow depth of field, I was able to accentuate the old man's hands and intensify the story they tell. The out-of-focus colonial architecture creates mood and setting.

7. *Cathedral Light*, Cholula, 1998

Photographed after nightfall in the courtyard of the San Gabriel Monastery. The evening service has just let out and people are leaving, illuminated by the light of the cathedral.

8. *Bird-Seller*, Mexico City, 2001

Santhosh—the editor of this project—and I were in San Ángel, a *colonia* just south of the centro, when we saw this man on his way home. How many birds had he raised, how many did he sell that day?

9. *Theatre Doors*, Oaxaca, 2000

The Teatro Macedonio de Alcala in Oaxaca was constructed in 1903–1909 with a late-nineteenth-century Parisian design. A tip for the guard allowed me to wander at will and take several strong images— I can almost hear the cheerful crowd and performance within.

10. *Cacophony of Birds*, Campeche, 2001

In some cities the birds come out at dusk or dawn and for a brief period, chirp so loudly that it is impossible to hold a conversation. In Campeche they seemed to burst forth from the trees like so many musical notes. In order to shoot this at the necessary speed of 500th of a second (the fastest available on my Hasselblad), I used the slightly grainy Ilford 3200 film.

11. *Sheet Music*, Mérida, 2001

Sunday in the zócalo: I wanted to capture the languid afternoon, the breeze, the sound of music, and the good spirits all around.

12. *Harbor Bench*, Veracruz, 1998

On the Malecón, this old bench contrasts with the distant, bright lights of the new and active port of Veracruz. During this trip I attempted to follow the route of Cortés from Veracruz through the cities of Jalapa, Tlaxcala, Cholula, Puebla, and on to Mexico City.

13. *Gathering Light*, Zacatecas, 1997

Zacatecas is an old silver mining city that still maintains an air of bourgeois wealth. I like the ambiguity of this photograph: the people are like insects drawn to the flame, while the solitary lamppost in the European-style courtyard echoes Magritte.

14. *Bike Shadow*, Motul, 2001

At dusk, families of three and four were stacked on bicycles, riding around the zócalo. As photographic subjects, shadows and reflections are more than simple ornament—often doppelgänger, they convey objects and scenes from another perspective.

15. *Night Shadows*, Guanajuato, 1997

A twisting, irregular city built on a number of hills, marked by a labyrinth of streets, underground roads, and walkways set in dry stream beds. The angular shadows, cobblestones, cars, and person reading are both incongruous and typical. A night photograph with an exposure of roughly three seconds.

16. *Shadow of the Fiesta*, Chiapa de Corzo, 2000

At three in the morning, while following a procession of the saints that included idols, firecrackers, and candles, I stopped to record this shadow of the fiesta.

17. *Turning Carousel*, Tlaxcala, 1998

Tlaxcala is a small capital city in Mexico known to some as the setting for the book *Under the Volcano*,

by Malcolm Lowry. This photograph, taken just past dusk in the Plaza de la Constitución, had an exposure of several seconds.

18. *Horse Rail*, Mexico City, 2001

This relic of time past gleams in the light of streetlamps.

19. *Loveseat*, Valladolid, 2001

Photographed at night after the rain, this tête-à-tête seems a perfect symbol of local culture: young couples meeting in the park to look, but not touch—too much.

20. *Carvajal Stairs*, Campeche, 2001

In a beautiful old mansion (now used as a government building) stand these magnificent stairs. I wanted to capture the feel of ascending and descending movement; a slow shutter speed of a half to one second will often freeze a hand or a foot while the body blurs.

21. *Cathedral Fiesta*, Valladolid, 2001

Taken at dawn, this image uses sight lines of the festival flags to create an extremely three-dimensional image. The clock tells the time.

22. *Angel*, Guanajuato, 1997

Angel in a private sanctuary: its serene power seems to hold the cracked wall together.

23. *Magic*, Pátzcuaro, 1996

I found this strange spectacle, where temporal and spatial relations seem slightly out of whack, in a church. Scale of objects is important, both in composition and size of photographic prints.

24. *Dungeon*, Campeche, 2001

Beneath the Baluarte de San Carlos is this dungeon, a testament to the legacy of Spanish cruelty in Mexico. The sole entrance to the room is the four-foot-high passageway seen in the photograph. In this very humid and unpleasant place, the camera lens required constant wiping. The only light source is the single dim, bare bulb.

25. *Eastern Cannon*, Campeche, 2001

For this dawn photograph, a necessarily long exposure created an unusually smooth and serene sea. I then printed this image in reverse because the composition is much stronger with the visual action left to right, in the same direction most of us read. The effect is to pull the viewer into the image rather than out of it.

NOTES ON THE PLATES

26. *Maqroll at Rest*, Salina Cruz, 2000

Salina Cruz is a small oil and fishing town on the Pacific. Arriving before dawn at the docks, I made this image: a collage of masts on slightly dilapidated boats, punctuated by a solitary, resting figure. I was immediately reminded of Alvaro Mutis's protagonist Maqroll, the Gaviero (or Lookout). The image is made crisp by the curious mixture of dawn in the distance and a large, overhead sodium vapor (or similar light) casting an eerie green-orange glow across the dock.

27. *The Undertaker Rises Early*, Morelia, 1996

For several generations central and northern California has been connected to the Mexican state of Michoacán by laborers who work in the agricultural fields of the Salinas Valley, San Francisco, and elsewhere. On the midnight, direct flight from San Francisco to Morelia, I was the only non-Mexican as locals returned home with heavy suitcases, televisions, and appliances. Arriving in Morelia before dawn, I found the hotels still closed and so wandered the old quarter. I took several frames of this undertaker before he shooed me away.

28. *Christ and Devotee*, Mexico City, 2001

This inner sanctum to the church, replete with symbolism, felt lush and timeless. The foot of a woman praying in the foreground pulls the viewer from past to present.

29. *Woman Leaning,* Izamal, 2001

A very simple shot taken after a procession to the sixteenth-century Convent of Saint Anthony. During the procession, rockets and firecrackers were lit; one flew a little low and through the round stained glass window at the front of the church, missing the Virgin's head by inches. It was fixed in a matter of hours. Note the remains of early murals on the walls.

30. *Schoolgirls*, Motul, 2001

The chiaroscuro effect on the trees and horse-drawn carts in the foreground provides a visual framework for the narrative aspect of the photograph, namely, the schoolgirls and other figures in the distance. This image strikes me as a metaphor of modern Mexico as seen through the architectural-cultural veil of its past.

31. *Water Jug (with memories of Gabriel García Márquez)*, Tehuantepec, 2000

It was a hot and dusty afternoon and this water jug sat in the shade outside an old church. Old colonels put out to pasture need water, travelers and children find respite in the shade. Is this jug of water set out by the priest in the spirit of Christian charity or to bait the unsuspecting?

32. *Painted Tree*, Valladolid, 2001

In 1996 I was in Pátzcuaro and had a dream about the painted trees of Mexico—they seem to symbolize the desire to impose order on natural landscapes.

33. *Cathedral Bells*, Mérida, 2001

The priest in the Catedral San Idelfonso graciously allowed the watchman to take me up into the tower and onto the roof. In the tower I found these beautiful bells. This photograph was very difficult to make because of contrast issues, plus I had only fifteen minutes before the deafening toll of noon bells. Ilford HP5 film pulled two stops, developed in a 1:3 C76 solution.

34. *Ancient Footprints*, Tehuantepec, 2000

Around this entrance to a sixteenth-century monastery, bricks are worn away by four hundred years of monks shuffling through the doorway. The picture is intentionally askew to suggest movement.

35. *Cenote Zaci*, Valladolid, 2001

These stairs lead from an underground limestone cistern (cenote) that once provided water for both Mayans and colonials. For me, stairs, windows, and doorways are a dangerous trap because they are so seductive in their metaphoric quality but have a tendency toward cliché.

36. *Siesta*, Real de Catorce, 1997

Waking from a delicious siesta in Real de Catorce—a mostly abandoned mining town perched at an elevation of 9,000 feet—I saw this play of light in the window area of the old hotel where I was staying. Working during the night invariably led to long siestas during the day, which in turn segmented my waking and sleeping hours and brought these two states of mind closer together.

37. *Leaf Shadow*, Jalapa, 1998

The single-point light source of a streetlight helped create this beautiful shadow. The difficulty in making this photograph, once it was visualized, was twofold: I needed depth of field but couldn't use a very long exposure, as the leaves were moving in the breeze.

38. *Siesta II*, Puebla, 1998

Waking from a siesta in this most European of Mexico's cities, I saw this multitextured photograph through the eyes of Matisse.

39. *Maritime*, Veracruz, 1998

I made this image by streetlight, in a park honoring the seamen of Veracruz.

40. *Typesetter*, San Cristóbal de las Casas, 2000

In a stall at the market the weekly paper is printed by hand. In an age of superfluous technology in Mexico and elsewhere, this image harks back to the essential elements from which such technologies are derived.

41. *Fish Market*, Salina Cruz, 2000

The odd juxtaposition of fish and feet deconstruct this image into its basic elements. Including more or less of the subject is not necessary to complete the scene: head, hands, or fish tails can be added through the mind's eye. This photograph was made at dawn, when fish are sold and before the heat of the day begins.

42. *Hielo*, Guanajuato, 1997

The ice machine in this jungle setting seemed both significant and, at the same time, totally absurd.

43. *Government Archive*, Campeche, 2001

The caretaker of this library/archive couldn't understand why I wanted to photograph in her room—a place where hardly anything happens and that is typically visited only by her friends. I like the contained history that combines with beautiful patterns of the labels; a shallow depth of field was used to accentuate this pattern.

44. *Bananas*, Veracruz, 1998

In this night photograph, simple fruit conjures thoughts of plantations and multinational exploitation.

45. *Chessboard*, Taxco, 1998

Inside the Santa Prisca Church, the stones and ball in this image seem to combine pre-Columbian and colonial leisure activity. Built with funds supplied by José de la Borda, founder of the legendary San Ignacio silver vein that brought fortune hunters to Taxco in the 1700s, the Santa Prisca Church covers the Socavon del Rey, the first gold and silver mine established by Spaniards in the New World.

46. *Alhóndiga de Granaditas*, Guanajuato, 1996

The heads of Father Miguel Hidalgo and three of his comrades—Juan Aldama, Ignacio Allende, and Mariano Jiménez—once hung from the four corners of this granary. Popular history says that the heads of these first insurgents in Mexico's War of Independence hung in place for nine years and seven months. Family history notes that Juan Aldama and Ignacio Allende are ancestors of Frederick Luis Aldama, author of the essay included with this collection.

47. *Confirmation*, Morelia, 1996

Important families of Morelia gather for a fiesta in the courtyard of this splendid colonial hotel. The play of children is timeless, while the courtyard itself is distinctly Mexican. I poached this image from a balcony.

48. *Walking the Tracks*, Tehuantepec, 2000

The British once built a railroad connecting both coasts of the Tehuantepec Isthmus, a route of transport that went out of favor after completion of the Panama Canal. Now the tracks are used only as a walking path between communities and, in the center of Tehuantepec, as a staging area for the daily market.

49. *Smile II*, Oaxaca, 2000

Dancers at dusk in the zócalo of Oaxaca. The radiant smile of this girl attracted my camera like a magnet. Everything else is accompaniment.

50. *Shave-Ice Vendor*, Chiapa de Corzo, 2000

The wall and the iron rail—I took a number of strong images in this location as various characters from the city strolled by.

51. *Flowers Are Like Children*, Tehuantepec, 2000

This is one of the few regions of Mexico with a traditional matriarchal society. When this woman asked why I was taking her picture, I replied that flowers seem like children and thought of my four-year-old son at home.

52. *Theatre Stairs*, Oaxaca, 2000

This image was taken with a 50 mm wide-angle lens. The camera angle is intentionally askew to accentuate a sense of vertigo.

53. *Street Light*, San Cristóbal de las Casas, 2000

Taken just past dusk when a light mist was falling, this image was made during a period of time when I was exploring the angular juxtaposition created when taking downward-pointing (bird's eye view) images.

54. *Colonial Noir*, San Luis Potosí, 1998

I arrived in the provincial capital of San Luis Potosí, a large city with a well-preserved colonial center and more than a million inhabitants, after a day-long bus ride. Taken in the evening by streetlight, this photograph of a cathedral captures the darker mood of Mexico's colonial past.

55. *Playground*, Valladolid, 2001

In the shadow of the Church of San Bernardino de Siena rests this playground, the past and future intertwined.

56. *Billares Estrello*, Matahuela, 1997

Who are these people who sing with guitars in the street and play billiards into the night? Hiding in the shadows, I got off one good frame before the presence of my camera encroached on the moment.

57. *Café Society*, Mérida, 2001

Whether one is having breakfast, a café, or a cerveza, the importance of cafés surrounding the zócalos in Mexico cannot be underestimated. I was happy to find this image, and I spent several afternoons in this café, drinking beer with a one-armed Irish photojournalist.

58. *Reader*, Mérida, 2001

Sunday, early evening and the zócalo was crowded. Using a 150 mm lens and Ilford HP5 film pushed to 800, I was able to photograph this old man without intruding on the scene.

59. *Bound Book*, Mexico City, 2001

Desiring an image of an ancient library, I found my way to the Medical Museum in Mexico City (formerly the School of Medicine and infamous for being a site central to the Inquisition in Mexico). This image was shot with a shallow depth of field to highlight the one volume carefully held together by a piece of string. What knowledge does this volume hold that caused it to be used more than the others?

60. *Two Cellos*, Motul, 2001

The *Diario de Yucatán* is the local paper. Bound into giant books in this library's archive, the newspaper shares space with musical instruments owned by a local group that uses the library's courtyard for practice.

61. *Watchtowers*, Campeche, 2001

Dusk at Fort San Miguel; in front of the tower stands a guard, and in the distance are the lights of the city.

62. *Pinocchio*, Mérida, 2001

The inside of Casa de Lagarto (House of the Alligator), a landmark colonial mansion that has fallen into moderate disrepair, is stocked with relics, statues, and antiques, which I understand Sr. Emilio Lamk (son of the Lebanese trader who originally purchased the mansion) buys but rarely sells. Having a limited amount of time, I was somewhat overwhelmed as I tried to choose among so many subjects.

63. *The Watchtower*, Campeche, 2001

The many forts of Campeche were built in defense against pirates who often overran the city. Taken at dusk, this image required that the electric light in the tower be balanced with the surrounding ambient light, which was fading rapidly.

64. *Stone Cutters Composition II*, Guanajuato/San Miguel de Allende, 1997

The cutting of stones and statue-making seems to be an art uninterrupted by the course of Mexican history. This stonecutter's "workshop," open to the elements, was on the high plateau, alongside the road between the sister cities of Guanajuato and San Miguel de Allende.

65. *They Say She Lost Her Head in the Revolution*, Mérida, 2001

This image was taken in front of the Casa de Lagarto. Sr. Lamk was most gracious when I introduced myself at his door, and not only allowed me to enter and photograph but also served me a delicious cup of Cuban coffee.

66. *Resting in the Doorway*, Oaxaca, 2000

Sitting behind the Ex-Convento de Santo Domingo at midday, a worker takes his lunch break. Fuji 645 camera used.

67. *Secrets*, Cholula, 1998

Cortés vowed to replace every indigenous temple in Cholula with a Christian church; in this town, Spanish towers dominate everything except the undertone. At dusk, crossing the courtyard of the San Gabriel Monastery (founded in 1549), workers and students head home—and what do these women whisper to one another?

68. *Escape*, Mexico City, 1998

While most of Mexico feels very safe for wandering and photographing in the late night or early morning, Mexico City is different. The image is an attempt to express the sense of foreboding that sat on my chest the few times I ventured out at night with my camera.

69. *Worker*, Morelia, 1996

A worker in the centro, passing through the architecture of his ancestors.

70. *Cartas*, Oaxaca, 2000

This nighttime image calls to mind Europe, old stamps, and postcards from travelers.

71. *Night Benches*, Guanajuato, 1996

Photographed at dawn under shadows both hard and soft, these benches could speak volumes if they were able to talk.

72. *Keys to the Tower*, Mérida, 2001

Murals inside this church, called the Church of the Third Order, have a definite Moorish feel. For me, the mystery of this picture rests in the small set of keys hanging just inside and to the left of the door.

73. *Old Friends*, Guanajuato, 1996

Guanajuato is a city of music, with its opera, symphony, nighttime serenaders, marching bands, and instrument makers. As a photographer, I rely on sophisticated tools; I feel a kinship with these musicians, who walk home after a performance casually carrying their own specialized tools like old friends.